D1239241

ILLUMINATIONS

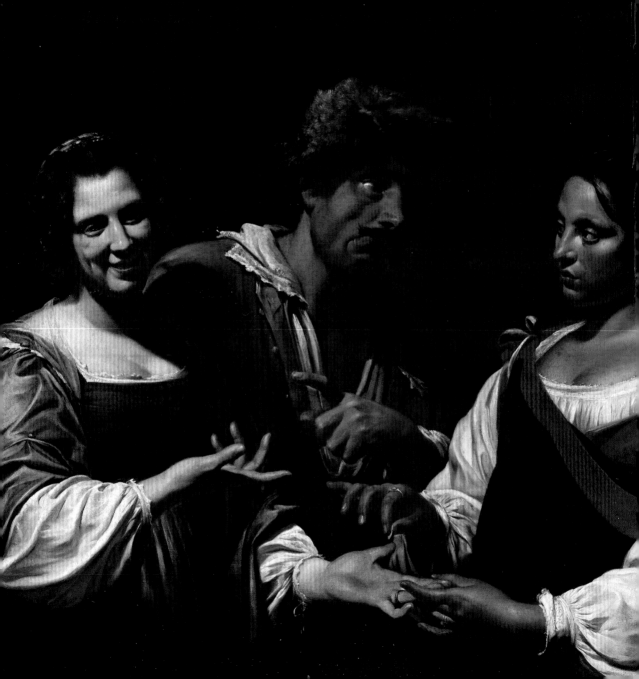

ILLUMINATIONS

Italian Baroque Masterworks in Canadian Collections

Edited by Benedict Leca
Essays by Devin Therien, C. D. Dickerson III, and Lloyd DeWitt

Art Gallery of Hamilton in association with D Giles Limited, London

This catalogue accompanies the exhibition
*Illuminations: Italian Baroque Masterworks
in Canadian Collections.* The exhibition was
created by Benedict Leca.

Exhibition dates
– Art Gallery of Hamilton, Hamilton:
 February 21 to May 31, 2015
– Art Gallery of Alberta, Edmonton:
 June 26 to October 5, 2015

© 2015 Art Gallery of Hamilton

First published in 2015 by GILES
An imprint of D Giles Limited
4 Crescent Stables,
139 Upper Richmond Road,
London SW15 2TN, UK
www.gilesltd.com

Library and Archives Canada Cataloguing
in Publication

Illuminations (2015)
 Illuminations : Italian Baroque
masterworks in Canadian collections / edited
by Benedict Leca ; essays by Devin Therien,
C.D. Dickerson III, and Lloyd DeWitt.

Catalogue of an exhibition held at the Art
Gallery of Hamilton from
 February 28 to May 31, 2015.
Includes bibliographical references and index.
ISBN 978-1-897407-16-5 (pbk.)

 1. Painting, Italian–Exhibitions. 2.
Painting, Baroque–Italy–Exhibitions.
3. Painting–Collectors and collecting–Canada–
Exhibitions. I. Leca, Benedict,
editor II. Therien, Devin, 1979- . Light and
shadow in Italian Baroque painting.
III. Art Gallery of Hamilton, issuing body, host
institution IV. Title.

ND616.5.B3I45 2015 75
9.5074'71352 C2014-
908017-4

ISBN 978-1-907804-57-1

All rights reserved

No part of the contents of this book may be
reproduced, stored in a retrieval system, or
transmitted in any form or by any means,
electronic, mechanical, photocopying,
recording, or otherwise, without the written
permission of the Board of Trustees, Art Gallery
of Hamilton, and D Giles Limited.

This exhibition was conceived by Benedict
Leca, former Director of Curatorial Affairs,
Art Gallery of Hamilton, and co-curated by
Benedict Leca and Devin Therien.

For Art Gallery of Hamilton
Editor: Benedict Leca
Co-Curators: Benedict Leca and Devin Therien

For D Giles Limited
Copyedited and proofread by Jodi Simpson
Designed by Alfonso Iacurci
Produced by GILES, an imprint of
D Giles Limited, London
Printed and bound in China

All measurements are in inches and centimeters

Front cover: Luca Giordano, *Massacre
of the Children of Niobe*, c. 1685 (pl. 1)

Frontispiece: Simon Vouet, *The Fortune-Teller*,
c. 1620 (pl. 3)

CONTENTS

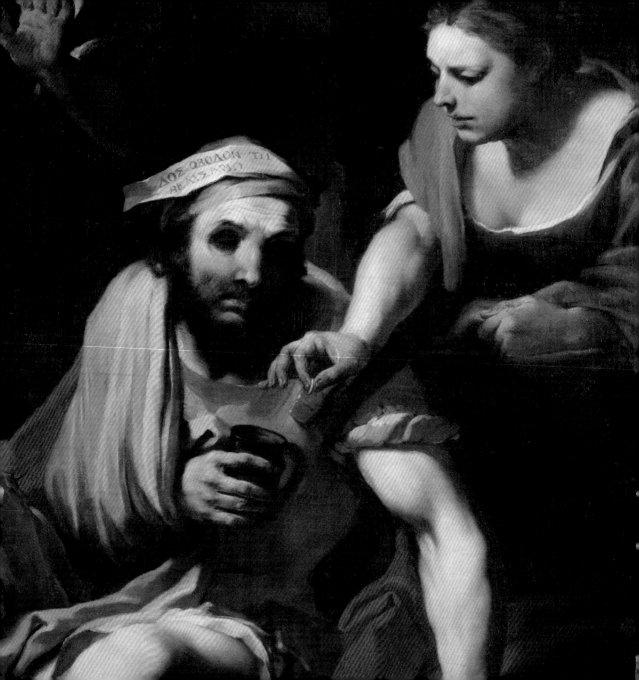

We are extremely proud to present one of the rare exhibitions of Baroque art in Canada.

Since receiving a major collection of art from Joey and Toby Tanenbaum in 2002, the Art Gallery of Hamilton has researched and featured numerous exhibitions of European art primarily from its nineteenth-century collection. *Illuminations* expands our explorations of European art by bringing into sharp focus Baroque works collected by Canada's leading art museums, including works from our own collection.

It is said that the seventeenth century "could be called the first modern age." Certainly, Baroque art, in contrast to previous art movements, is an explosion of form on canvas. Infused with a sense of energy and immediacy, the works tend to stand in strong contrast to previous forms of representation. Within this context, *Illuminations* examines the broad use of light in Italian Baroque painting, and its meaning and influence on early modern art. By extension, the exhibition also explores collecting practices in Canadian art museums and the representation of Baroque art in these collections. There is no question that most Canadian institutions are severely limited in their ability to focus on this fascinating era of art-making; hence this project is of even greater interest to everyone.

Conceived by Dr. Benedict Leca, former AGH Director of Curatorial Affairs, and co-curated by Dr. Leca and Dr. Devin Therien, a graduate of Queen's University, *Illuminations* is an exemplary collaborative endeavor that enriches curatorial practice in this country. We are truly grateful to both for their deep commitment to the success of this exhibition.

Equally important was the generous response received from our sister institutions including the Art Gallery of Ontario, the Montreal Museum of Fine Arts, the Agnes Etherington Art Centre, and the National Gallery of Canada. Our sincere thanks and appreciation to all the lenders to this exhibition; without their willingness to share their precious artworks with us, this project would never have been realized. We are also delighted that the Art Gallery of Alberta will be hosting this exhibition.

Once again, we are very pleased to be working with D Giles Limited for the production and distribution of the book, ensuring a broad reach worldwide.

We are deeply grateful to the Department of Canadian Heritage Museums Assistance Program for their financial assistance. This grant together with support from the City of Hamilton, the Ontario Arts Council, and the Canada Council for the Arts made this exhibition possible.

—

Louise Dompierre, *President and CEO*
Art Gallery of Hamilton

http://www.artgalleryofhamilton.com/docs/illuminations_italian_baroque_masterworks_in_canadian_collections.pdf

Pl. 10 (detail)

7

Le Musée des beaux-arts de Hamilton est très fier de présenter l'une des rares expositions consacrées à l'art baroque au Canada.

Depuis qu'il a reçu en don une importante collection d'œuvres de Joey et Toby Tanenbaum, en 2002, le Musée a réalisé de nombreuses expositions sur l'art européen, principalement en lien avec sa collection du xixe siècle. L'exposition *Illuminations* poursuit maintenant cette exploration de l'art européen en mettant en valeur les œuvres d'art baroque conservées dans les grands musées d'art au Canada, notamment les œuvres de notre propre collection.

On dit du xviie siècle qu'il serait la « première modernité ». Chose certaine, l'art baroque, contraire- ment aux mouvements artistiques qui l'ont précédé, est une réelle explosion de formes sur la toile. Imprégnées d'énergie et de spontanéité, la plupart des œuvres de cette époque contrastent fortement avec les formes de représentation antérieures. Ainsi, *Illuminations* s'intéresse à la grande utilisation de la lumière dans la peinture baroque italienne, à sa signification et à son rôle dans la naissance de l'art moderne. Par le fait même, l'exposition se penche sur les pratiques de collectionnement des musées d'art au Canada et sur la représentation de l'art baroque au sein de leurs collections. Il va sans dire que la plupart des institu- tions canadiennes ne disposent pas des ressources nécessaires pour étudier à fond cette fascinante période de création; ce qui rend ce projet d'autant plus intéres- sant pour tout un chacun.

Conçue par Benedict Leca, ancien directeur de la conservation du MBAH, et préparée par ce dernier con- jointement avec Devin Therien, diplômé de l'Université Queen's, cette exposition est le fruit d'une collaboration exemplaire, qui vient enrichir la pratique de commis- sariat au pays. Nous souhaitons exprimer notre sincère gratitude à tous les deux pour leur engagement à mener à bien cette exposition.

Tout aussi importante est la réponse généreuse que nous avons obtenue de la part de nos institutions sœurs, dont le Musée des beaux-arts de l'Ontario, le Musée des beaux-arts de Montréal, l'Agnes Etherington Art Centre et le Musée des beaux-arts du Canada. Nos remerciements et notre reconnaissance vont également aux prêteurs qui, en acceptant de partager leurs précieuses œuvres, ont permis à ce projet de voir le jour. Nous sommes par ailleurs ravis que le Musée des beaux-arts de l'Alberta accueille l'exposition.

Encore une fois, nous sommes très heureux de collaborer avec D Giles Limited à la production et à la distribution de cette publication, assurant ainsi son rayonnement partout dans le monde.

Nous remercions vivement le ministère du Patrimoine canadien pour son appui dans le cadre du Programme d'aide aux musées. Cette subvention, combinée au soutien de la ville de Hamilton, du Conseil des arts de l'Ontario et du Conseil des arts du Canada, a rendu possible cette exposition.

—
Louise Dompierre, *Présidente et directrice générale*
Musée des beaux-arts de Hamilton

http://www.artgalleryofhamilton.com/docs/illuminations_chefs_ doeuvre_baroque_italiens.pdf

ACKNOWLEDGEMENTS

The Art Gallery of Hamilton wishes to thank the City of Hamilton, its members, and friends. As well, it is grateful for the generous assistance of the Canada Council for the Arts and the Ontario Arts Council.

Le Musée des beaux-arts de Hamilton remiercie la Ville de Hamilton de même que ses membres et ses asmis. Sa gratitude va également au Conseil des Arts du Canada et au Conseil des arts de l'Ontario pour leur appui constant.

Lending Institutions: Agnes Etherington Art Centre, Queen's University, Kingston; Art Gallery of Ontario; The Montreal Museum of Fine Arts; National Gallery of Canada

Organizers wish to thank the following: Danielle Blanchette, Stephen Boris, Steve Denyes, David DeWitt, Lloyd DeWitt, C. D. Dickerson III, Stephanie Dickey, Louise Dompierre, Christopher Etheridge, Hilliard Goldfarb, Wendy Hebditch, Paul Lang, Chantelle Lepine-Cercone, Timothy Long, Leora Maltz-Leca, Janet Mowat, Marilyn Nazaar, Salvador Salort-Pons, Sebastian Schütze, and Robert Swain

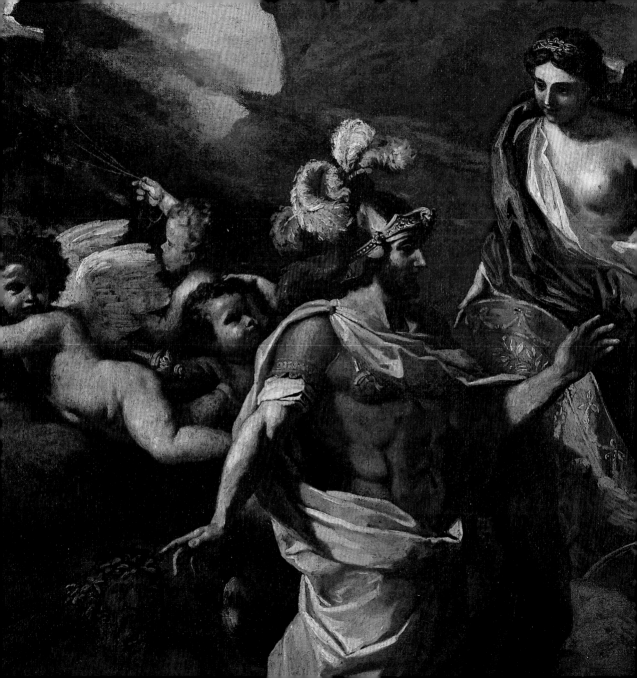

PLATES

1

Luca Giordano (Italian 1634–1705)
Massacre of the Children of Niobe, c. 1685
Oil on canvas
68¹⁵⁄₁₆ × 101¹⁵⁄₁₆ in. (175 × 259 cm)
Art Gallery of Hamilton, Ontario
The Joey and Toby Tanenbaum Collection, 2002
2002.33.62
Photo: Roy and Carole Timm

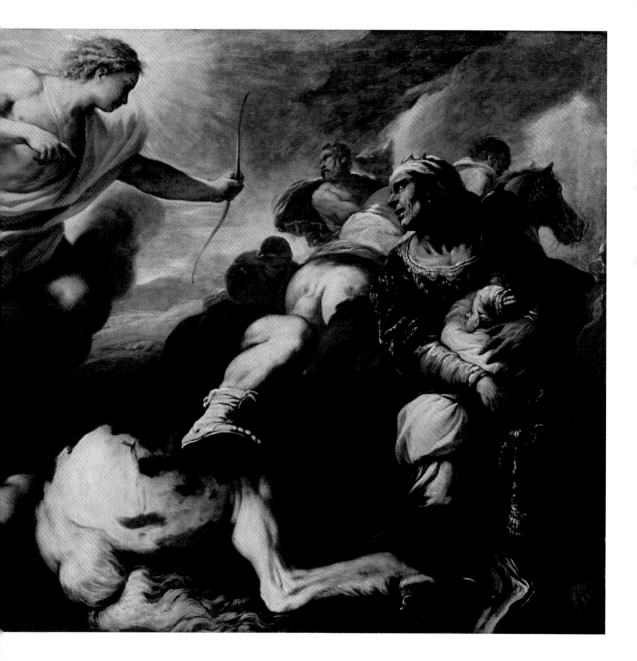

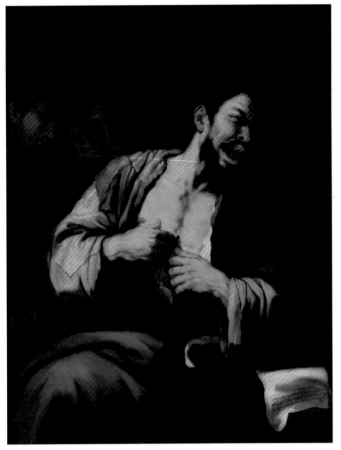

2

Luca Giordano (Italian 1634–1705)
Suicide of Cato, c. 1660
Oil on canvas
49 × 38¼ in. (124.5 × 97.2 cm)
Art Gallery of Hamilton, Ontario
The Joey and Toby Tanenbaum
Collection, 2000
2000.34.2
Photo: Robert McNair

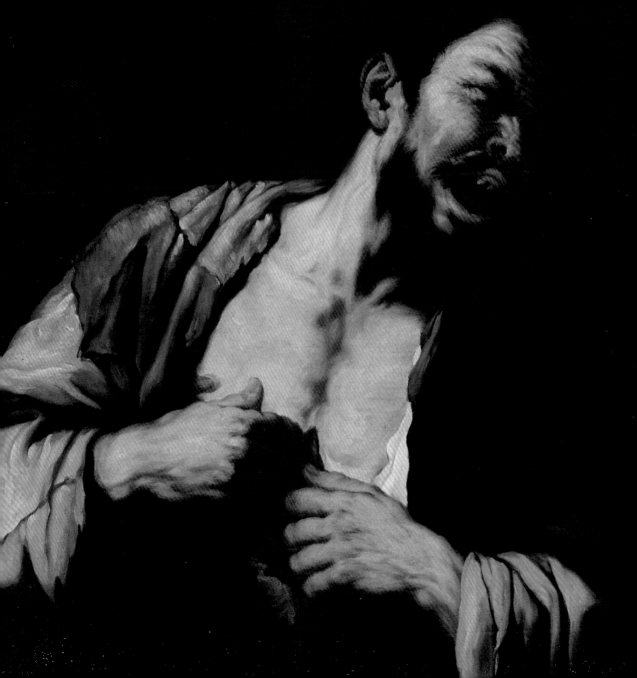

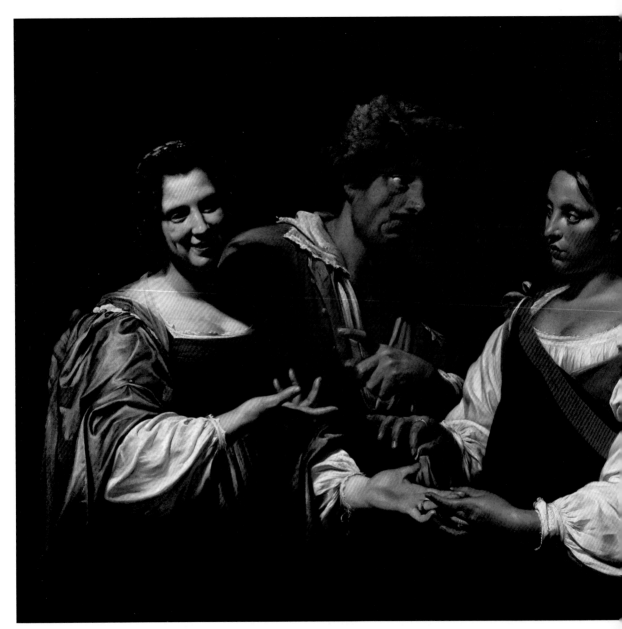

3
—

Simon Vouet (French 1590–1649)
The Fortune-Teller, c. 1620
Oil on canvas
47¼ × 67 in. (120 × 170.2 cm)
National Gallery of Canada, Ottawa
Purchased 1957
no. 6737
Photo © National Gallery of Canada

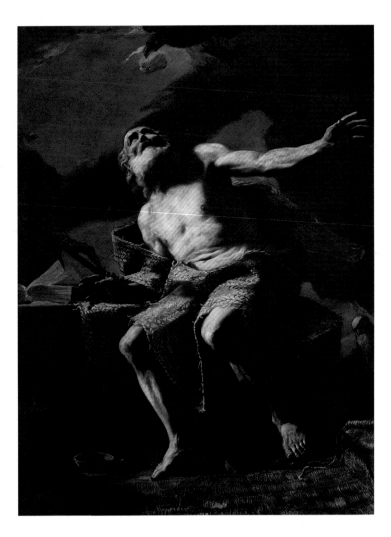

4
—

Mattia Preti (Italian 1613–1699)
St. Paul the Hermit, c. 1656–60
Oil on canvas
92 × 71¼ in. (233.7 × 181 cm)
Art Gallery of Ontario, Toronto
Purchase, Frank P. Wood Endowment, 1968
67/146
© 2014AGO

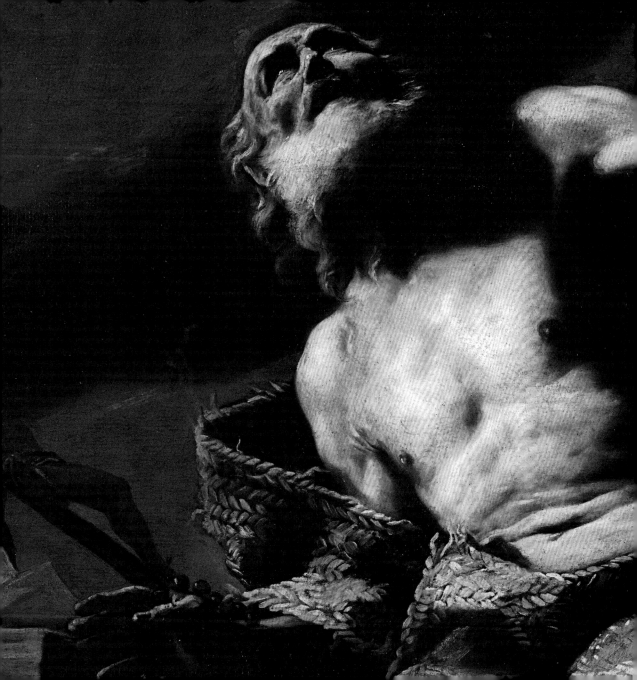

5
—

Giovanni Battista Langetti
(Italian 1625–1676)
Isaac Blessing Jacob, date unknown
50 × 66¾ in. (127 × 169.5 cm)
Art Gallery of Ontario, Toronto
Gift of Miss L. Aileen Larkin, 1961
61/12
© 2014AGO

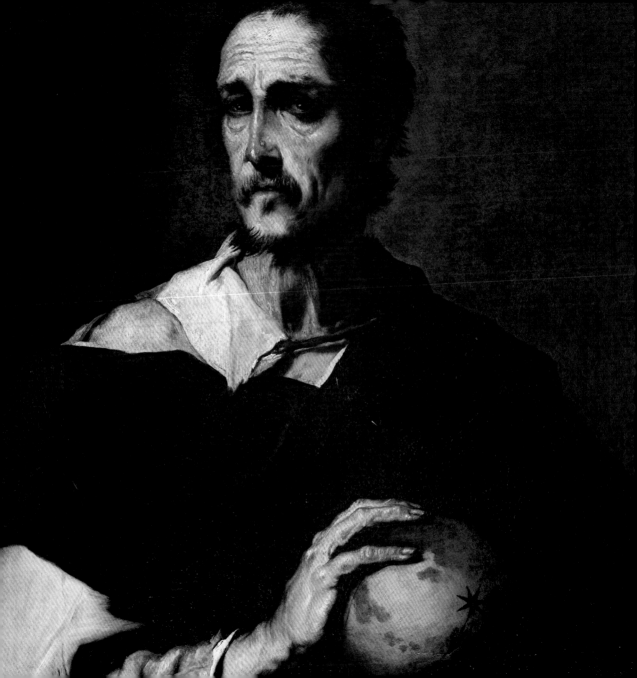

6

Luca Giordano (Italian 1634–1705)
Astronomy, c. 1653–54 or 1680–92?
Oil on canvas
50³/₁₆ × 39³/₁₆ in. (127.4 × 99.5 cm)
Art Gallery of Ontario, Toronto
Gift of Joey and Toby Tanenbaum, 1995
95/145′
© 2014AGO

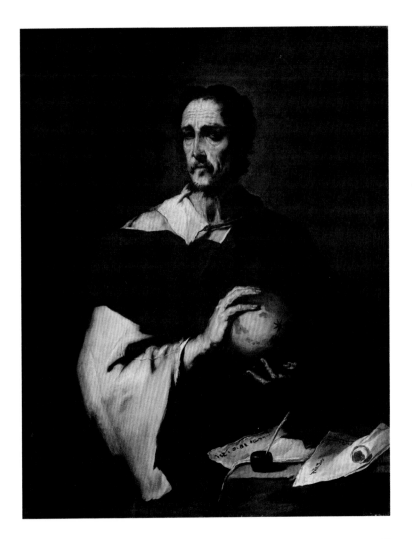

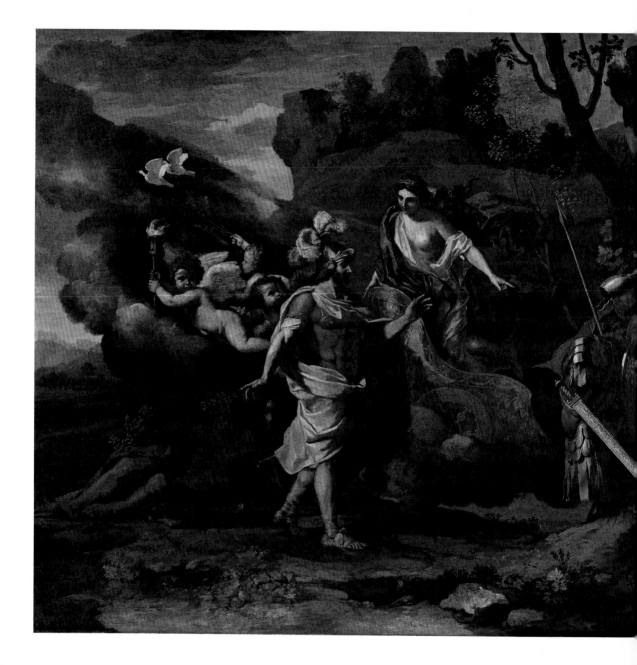

7

Nicolas Poussin (French, 1594–1665)
*Venus, Mother of Aeneas, Presenting
Him with Arms Forged by Vulcan,*
c. 1636–37
Oil on canvas
42½ × 53 in. (108 × 134.6 cm)
Art Gallery of Ontario, Toronto
Purchase, 1948
48/5
© 2001AGO

8

Giacinto Brandi (Italian 1621–1691)
The Weeping Heraclitus, c. 1690
Oil on canvas
47 × 36¹/₁₆ in. (119.4 × 91.5 cm)
Agnes Etherington Art Centre,
Queen's University, Kingston, Ontario
Gift of Alfred and Isabel Bader, 1991
34-020.18
Photo: Bernard Clark

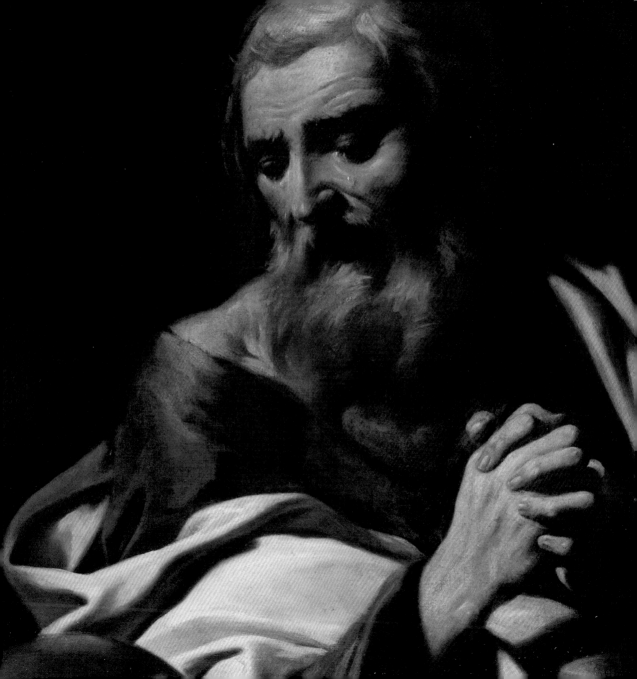

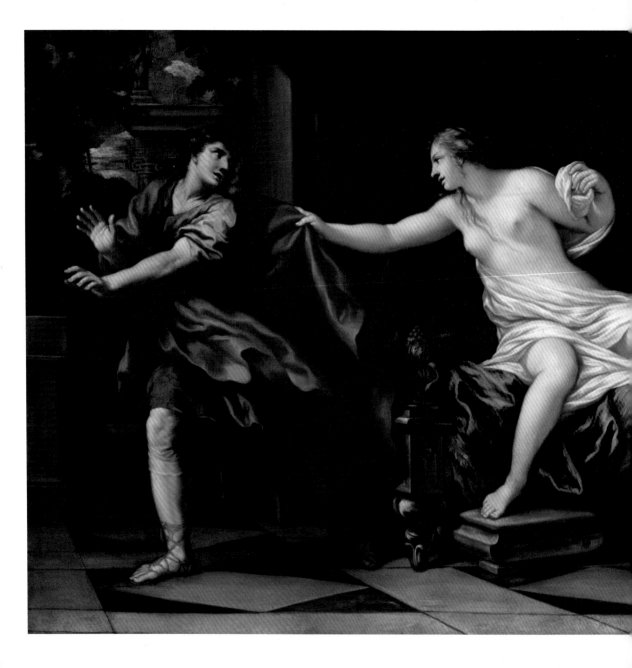

9

Ciro Ferri (Italian 1634–1689)
Joseph Turning Away from Potiphar's Wife, c. 1675
Oil on canvas
29¾ × 41 in. (75.6 × 104.1 cm)
Agnes Etherington Art Centre,
Queen's University, Kingston, Ontario
Gift of Dr. and Mrs. Alfred Bader,
1973
16-031
Photo: Bernard Clark

10

Andrea Lanzani (Italian, c. 1645–1712)
The Blind Belisarius, c. 1695
Oil on canvas
51$^{15}/_{16}$ × 66$^{15}/_{16}$ in. (132 × 170.1 cm)
Agnes Etherington Art Centre,
Queen's University, Kingston, Ontario
Gift of Dr. and Mrs. Alfred Bader
14-006
Photo: Bernard Clark

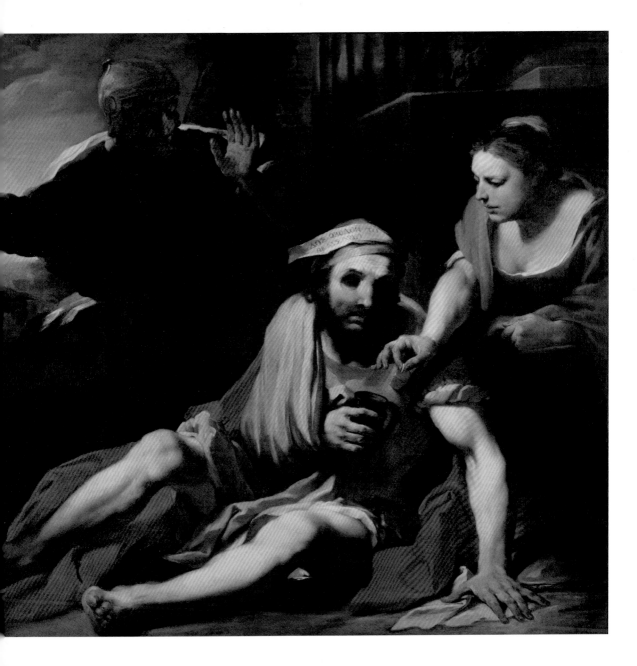

11

Matthias Stom
(Dutch, c. 1600–after 1652)
*Christ and the Woman Taken
in Adultery*, c. 1630–33
Oil on canvas
40 × 54 in. (101.6 × 137.2 cm)
The Montreal Museum of Fine Arts
Purchase, Horsley and Annie Townsend
Bequest and gift of Mr. and Mrs.
Michal Hornstein
1993.16
Photo: The Montreal Museum of
Fine Arts, Brian Merrett

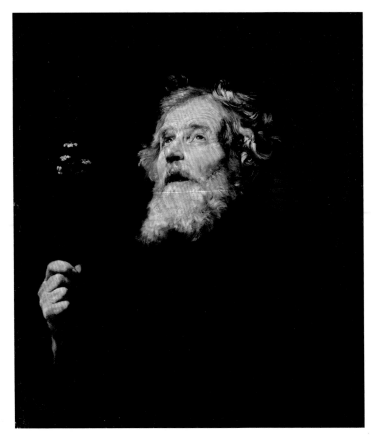

12

Jusepe de Ribera
(Spanish 1591–1652)
St. Joseph, c. 1635
Oil on canvas
28¼ × 24⅜ in. (71.8 × 61.9 cm)
The Montreal Museum of Fine Arts
William J. Morrice Bequest
inv. 1943.815
Photo: The Montreal Museum of
Fine Arts, Christine Guest

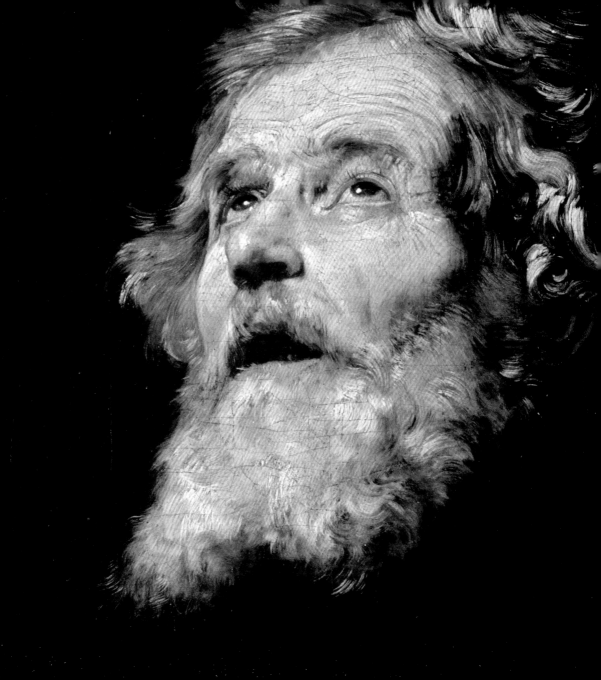

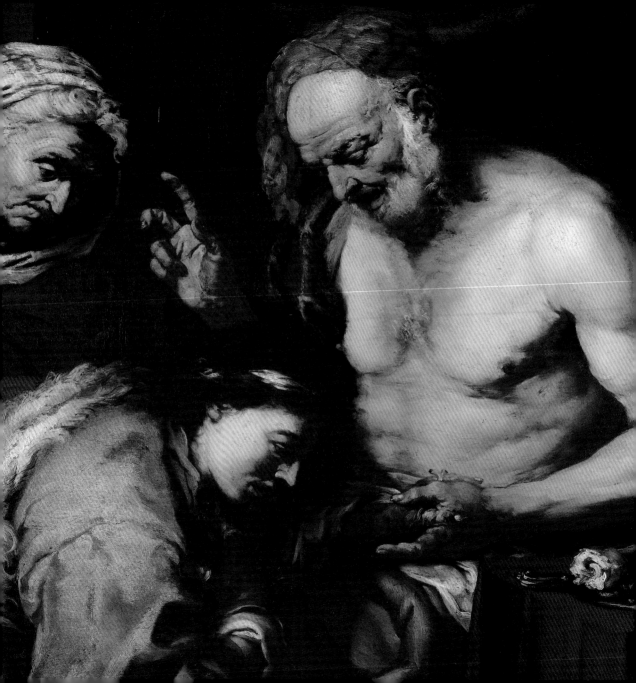

The archaeological record certifies that the use of light was coincident with the earliest picture making, in Paleolithic times, when cave artists used the circumscribed illumination and activating flickers of oil lamps to create dynamic narrative structures through which to engage viewers. If Italian Baroque painters also sought to engage viewers when they made light effects the signal characteristic of their art, it was of course for different reasons. It bears mention from the outset that the elastic term of Baroque brings under it many artists of vastly different approaches and personal styles, each navigating, in his or her mobilization of light, between the two fundamental poles of naturalistic and idealizing representation that defined the painting of the age. Yet the broader subtending context was largely the same for all: that is, the "Church triumphant," or a resurgent, popular Catholicism, the by-product of the Counter-Reformation of the preceding era. Among the Catholic Church's most important ecumenical councils, the famous Council of Trent (1545–63) had officially admitted the benefits of imagery to support religious teaching. This admission in turn engendered much aesthetic writing that established three basic prescriptions for any viable art, which in their end goal of public engagement made the functional and narrative use of light a logical component: 1.) Clarity, simplicity, and legibility. 2.) Realistic interpretation. 3.) Emotional stimulus to piety.[1]

In an era when any explanatory text accompanying a picture would offer little hope of conveying the desired moral lessons to a largely illiterate lay public, narrative clarity and legibility remained the bedrock requisite. Perhaps this had always been so. In his foundational text *On Painting*, for example, the Renaissance polymath Leon Battista Alberti affirmed that painted figures should "demonstrate their own feelings as clearly as possible," the better "to move spectators."[2] Yet Alberti remained constrained by decorum in a work devoted to the intellectual rationale for painting, one that largely precluded dramatic movement as well as any dramatic use of light, the latter discussed in his treatise in strictly scientific terms of color perception. By the seventeenth century, the unabashedly persuasive bent valorized by a Catholic Church now fully attuned to the propagandistic possibilities of art combined with more proximate artistic influences to create a context that authorized dramatic experimentation. To be sure, painters necessarily still partook of the long-established stock of conventional metaphors that would have light as truth or as symbolic of the divine, and its absence as an index of evil or ignorance. However, the moral instruction and "stimulus to piety" that drove church patronage, and the prevailing positivistic outlook adopted by a broad elite of private patrons, connoisseurs, and

Pl. 5 (detail)

theorists, set the stage for a ready acceptance, if not tacit encouragement, of painting that could be at once starkly naturalistic and highly theatrical.

Such a protean, experimental—one might even say permissive—artistic environment, characteristic of a period perceived today as the prefatory phase of the modern era ("early modern"), demands that our attention to light accounts for the variability of its uses and meanings across a spectrum that would surpass the reductive cleavage between the realism of Michelangelo Merisi da Caravaggio and the classicism of Annibale Carracci. The lesson is that artists forever traffic in artifice, employing formulas and conceits that often combine seemingly opposing modes of representation. For example, Mattia Preti's dramatic chiaroscuro (play of light and dark) defines a sinewy St. Paul responding to divine intervention in a scene that is as strikingly lifelike as it is utterly staged (see pl. 4). Likewise, while classicizing confections such as Guido Reni's *Jupiter and Europa* necessarily present idealized figures perfectly modeled by artificial lighting, they remain underpinned by enduring standards of naturalistic representation (see p. 47). Indeed, one of the foundational tenets of the Carracci Academy in Bologna, where Reni was formed, was the close study of nature and a deep understanding of anatomy, which Reni systematically engaged with through studies and preparatory drawings.[3]

The exceptional pictures gathered here—notable for their range of styles, subjects, and date of creation—ensure that visitors will experience the gamut of ways that painters mobilized light. Effects of light might be used to communicate religious and mythological narratives, or to accent their lessons through ancillary metaphors of light. For example, as the dominant protagonist in Luca Giordano's *Massacre of the Children of Niobe*, Apollo is readily identifiable as the divine archer of the myth, suffused in yellow light, his head accented by a halo of illuminating rays (see pl. 1). Yet painters also routinely put light effects to flatly functional purposes: to brighten their pictures and/or consolidate their compositions. In *Venus, Mother of Aeneas, Presenting Him with Arms Forged by Vulcan* (see pl. 7), Nicolas Poussin illuminated his entire scene with a bright daylight, rendered using passages of silvery white that accord with other elements, also painted using white, to create a unifying rhythm across his canvas.

Supporting this instructive range of paintings, this catalogue aims to present both a fuller picture of the contemporary artistic context and a brief sketch of the collecting of Baroque pictures in Canada. The lead essay by Dr. Devin Therien, co-curator of the exhibition, makes clear that the use of light effects in painting issued as much from the emergent scientific understanding of light as it did from established symbolism and the codes that

governed grand manner painting. C. D. Dickerson III, Curator of European Art at the Kimbell Art Museum, demonstrates how light effects, which one might presume were more closely tied to painting, were in fact an integral part of the sculptor's art, particularly that of Gian Lorenzo Bernini. Lloyd DeWitt, Curator of European Art at the Art Gallery of Ontario, reminds us of the impact of one kind of light on northern European art making, Caravaggio's tenebrism, which had as much influence on Northern artists as it did on those of Italy. Finally, Dr. Devin Therien traces the rich and long-standing history of the appreciation and collecting of Italian Baroque painting in Canada.

In this way, the present exhibition and its catalogue remind us—if a reminder were needed—not only of the inventiveness and subtlety of Baroque painters' adaptation of light effects, but also how fundamentally important the trope of illumination was for them and indeed for all Western artists. The thematic use of light and shade can be said to be the basis of the graphic arts in the West, just as it is surely the foundational metaphor of Western metaphysics, in which light is truth and darkness falsehood. Certainly, we might do well, in a final analysis, to reflect globally on the role of light and its meanings in generating beauty as well as fomenting social and religious tensions.

—

Benedict Leca

1. Rudolf Wittkower, *Art and Architecture in Italy 1600 to 1750* (Baltimore: Penguin, 1958), 1.
2. Leon Battista Alberti, *On Painting* (London and New York: Penguin, 1972), 76.
3. Jaynie Anderson, "Speculations on the Carracci Academy in Bologna," *Oxford Art Journal* 2, no. 3 (1979): 15–20.

ESSAYS

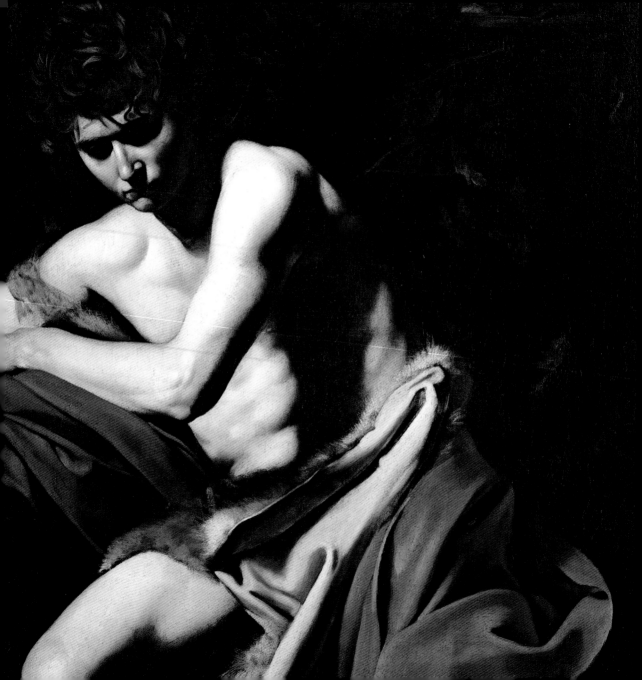

LIGHT AND SHADOW IN ITALIAN BAROQUE PAINTING

— DEVIN THERIEN

As far back as the Renaissance, Italian Old Master painters were concerned with the effects of light. In his treatise *On Painting*, Leonardo da Vinci (1452–1519) noted that light could not exist without the presence of shadow, as the presence of each was required in order to perceive all forms in space. After describing the various types of light, including that produced by the sun and that visible in the atmosphere, Leonardo pronounced:

> Shadow is of the nature of darkness and illumination is of the nature of light. The one conceals and the other reveals. They are always joined together in company on bodies, and shadow is of greater power than light, because it banishes and completely deprives bodies of light.[1]

In this statement Leonardo outlined a broadly recognized, but not scientifically understood, axiom about the role and function of light and shadow as it appears to the human eye, and specifically to artists' eyes. The importance of the relationship between light and shadow can be explained best by considering the Italian word *chiaroscuro*, meaning the degrees of contrast between light (*chiaro*) and shade (*scuro*). The term, originating in fifteenth-century Italian art theory, referred specifically to the distribution of light and dark values with which artists imitated illuminated and shaded objects. As Leonardo further noted, gradations of light and shade gave shape to objects, for those "seen in light and shade will be displayed in greater relief."

Subsequent investigations of light and shadow are equally important, as all forms of illumination determine the color of the material objects that

Fig. 1 (detail)

43

surround us. Later artists and natural philosophers discovered that the range of light the human eye registers is perceived as colors. As such, light and its absence not only define the three-dimensionality of objects, but also endow these objects with color. Studies of illumination have demonstrated that color, as naturally perceived, is a by-product of the different rays of light that illuminate objects. Isaac Newton's optical experiments, for example, demonstrated that a range of colors (red, orange, yellow, green, blue, indigo, and violet) are visible to the human eye when white light passes through a prism at different angles. Color, therefore, is a function of light, appearing and disappearing according to the conditions set by the source of illumination. While the scientific factors contributing to the human perception of light are far more complicated than outlined here, suffice it to say that a practical understanding of light, shadow, and their by-product color was essential for the pictorial representation of nature within an illusionistic space.

With the exception of Leonardo, artists were not natural philosophers and did not study optics and human perception scientifically, as Newton did. It is noteworthy to begin with Leonardo, since his writings, while widely circulated throughout the sixteenth and early seventeenth centuries, were compiled and published in the form of a treatise in 1651. Consequently, Italian Baroque artists were quite aware of Leonardo's conclusions about the role of light and shadow in nature and how it applied to painting. His observations might, then, be taken as foundational to the essays of Baroque painters after him. Yet painters, unlike natural philosophers, were interpreters of the effects of light. In such a capacity, they were able to selectively reproduce various sources of illumination for dramatic ends. The discussion that follows examines how painters used light as they interpreted and recreated the world in painting.

PAINTING LIGHT

Despite their ability to manipulate light on a canvas, painters needed to address three fundamental considerations in their depictions of illumination: the type of light being used or depicted—that is, natural light (daylight), artificial light (lamps, candles, torches), and supernatural light (unidentified by the illusionistic effects that are created); the light's intensity and whether the source of radiation focuses directly or indirectly upon an object; and the direction of the light, particularly that from which the source of radiation descends upon three-dimensional and illusionistic objects—from above or below, from the front, or from behind. As Leonardo's comments and those of his Renaissance successors indicate, verisimilitude (the appearance

of reality) was one the principal goals of Italian Renaissance painters.[2] Baroque artists, on the other hand, experimented with patterns of illumination more than their predecessors and successors, creating dramatic effects that radiated throughout the natural, supernatural, or mysterious spaces they depicted. By illuminating their compositions from the front, the back, the side, multiple sides, and from within, painters probed the limits of the effects of light on figures, objects, and spaces.

Many Italian Baroque painters depicted light within the pictorial field by organizing various colors in different combinations so that they might successfully reproduce the distribution of light and shadow as it would appear in nature. Some, however, recognized that the manipulation of illumination was the principal expressive means through which they could amplify their visual vocabulary and provoke extreme emotional responses to their paintings. In so doing, they created paintings that pushed the goal of verisimilitude to new levels of naturalism, depicting figures and objects in such detail that the veins, creases, and wrinkles of their protagonists' faces and arms captivated audiences. At the same time, other painters depicted social and historical events in a manner that idealized their figures and the environments in which the action took place. The latter approach emphasized the representation of an ideal world, one based in

Fig. 1
Caravaggio, *St. John the Baptist in the Wilderness*, 1605, oil on canvas, Nelson Atkins Museum, Kansas City

part on an art theory that celebrated the figural and literary example of Greco-Roman antiquity, as well as the art of such High Renaissance masters as Raphael (1483–1520).[3]

LIGHT AND SHADOW I:
THE DECORUM OF ILLUMINATION

Artists frequently developed new strategies of illumination by studying how light in nature affected the appearance of objects by, for example, constructing mock stages to compose scenes with wax figurines. However, some experiments and their resulting effects were not always critically appreciated, as the "decorum," or appropriateness, of illumination in painting, especially as it applied to the depiction of religious imagery, was a subject of constant debate. The issue of decorous and indecorous lighting was widely discussed throughout seventeenth-century Italy, as patrons, collectors, connoisseurs, and biographers compared such artists as Caravaggio (1571–1610) and, among others, Guido Reni (1575–1642). Caravaggio's tenebrous lighting boldly illuminated his clearly articulated and brilliantly colored figures in brightly lit and heavily shadowed spaces. His dramatic use of chiaroscuro, as exemplified by his *St. John the Baptist in the Wilderness* (fig. 1), was easily juxtaposed with that employed by the painters studying

with the Carracci family—Annibale (1560–1609), his older brother Agostino (1557–1602), and their cousin Ludovico (1555–1619)—including such protagonists as Domenichino (1581–1641) and Reni. The latter's silver illumination and chromatic brilliance (luster of colors) was expressed first and foremost by depicting radiantly colored figures in open and atmospheric environments. Reni's *Jupiter and Europa* (fig. 2) exhibits his unique pictorial brilliance, which enlivened his pictures through the pink, blue, orange, and purple hues, as well as a range of silver and golden shades derived from those of Raphael, Titian, and Federico Barocci (c. 1535–1612).

Caravaggio's paintings are perhaps most intriguing to viewers because of the dynamic relationship he created between darkness and light. These two elements became the defining characteristics of his art and that of an extraordinary number of artists that reinterpreted his ability to depict scenes with verisimilitudinous accuracy and clarity. Such painters as Bernardo Strozzi (1581–1644), Mattia Preti (1613–1699), and, among others, Matthias Stom (c. 1600–after 1652) demonstrated a particular interest in hypernaturalistic representations amplified by dramatic lighting effects. To greater or lesser degrees, each of these painters applied a highly artificial chiaroscuro that trained a beam of light, sharply descending from above, on an individual figure or a group gathered in a small

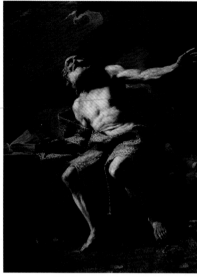

Fig. 2
Guido Reni,
Jupiter and Europa,
c. 1636

Fig. 3
Mattia Preti,
St. Paul the Hermit,
c. 1656–60 (plate 4)

space so as to throw their features into sharp relief while leaving the surrounding space in a mysterious shadow. Strozzi's *Village Musicians* and Preti's *St. Paul the Hermit* epitomize this technique (figs. 4, 3). Both depict figures that are so brightly lit that their hypernaturalistic features immediately capture the viewer's attention. The light magnifies the action and captivates viewers to such a degree that they may not question why the surrounding space is unidentified. Similar effects appear in Stom's *Christ and the Woman Taken in Adultery* (pl. 11), as the pervasive light illuminates the figures alone.

A number of artists and connoisseurs actively criticized this means of illumination and composition for being too contrived, including the Sienese dilettante Giulio Mancini (1558–1630). According to Mancini, Caravaggio and his reinterpreters, while demonstrating a "desire to illuminate with a single light that comes from above," depict their figures, forms, and illusionistic space in an "un-natural manner not completed nor thought out like those from other centuries or older painters like Raphael, Titian, and Correggio."[4] Mancini continued by noting that their fascination with naturalism and artificial light limited their abilities to execute grand paintings. Since the depiction of historical narratives was considered the noblest form of painting, artists from this school failed to obtain great stature, according to Mancini, because their pictures did not communicate emotion in a manner appropriate to the genre.[5] Such artists,

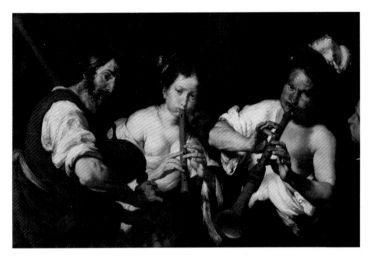

Fig. 4
Bernardo Strozzi,
Village Musicians, c. 1635,
oil on canvas,
Art Gallery of Ontario, Toronto,
on loan from a private collection

then, were seen as producing indecorous works, for their direct source of light, sharp division between illuminated and shaded spaces, and their emphasis on hypernaturalistic as opposed to idealized figures and compositions restricted their ability to compose historical narratives like those painted by Domenichino and Reni. Mancini, continuing his discussion, emphasized the superiority of the Carracci, and such students of theirs as Reni, because their paintings "assimilated Raphael's [naturalistic] style with that of Lombardy" and "left the worst and selected the best qualities" so "with natural light they endowed their paintings with emotion and grace and color and shade."[6]

The use of a single light source coming from above, the heavily shadowed and often opaque backgrounds, and artists' desires to maximize verisimili-

tude defined Baroque discussions of Caravaggesque painting. Mancini's blanket statement, tarnishing the reputations of all contemporaneous and successive painters who worked in the Caravaggesque mode, reflects his personal critical perspectives more than anything else. Despite the significant differences between the appearance of Strozzi's ruddy musical ensemble and Reni's idealized heroine, these two artists were united in their attempt to amplify their figures' appearances through dynamic lighting effects. Reni used a diffuse light that radiates broadly throughout the entire scene. His fascination with brilliant tonal variations is clearly exemplified by the *Jupiter and Europa*. The utter silence of Europa's upward gaze and static posture contrasts with her radiantly colored vestments that billow open and

upwards. Like many of his mythological works, Reni's picture contains an amplified radiance, which enhances the secondary hues that dominate his vibrant palette. The painter's lighting and its corresponding influence on the appearance of his colors is central to understanding his pictorial strategies. Unlike Strozzi's brilliantly lit yet spatially isolated figures, Reni's broadly illuminated illusionistic space attracts the viewer's attention, compelling him or her to experience the breadth of this abduction scene. At the same time, the colored garments elevate the emotional tenor of the subject via the combination of pink, orange and cool purples. In short, the *Jupiter* is an important example of how luminosity directly affects chromatic brilliance (luster of colors), which, in turn, contributes to the emotional charge of a painting.

LIGHT AND SHADOW II: ILLUMINATING PAINTING AS SCULPTURE

By deploying an intense form of light, the bright and dark areas vividly juxtapose a figure's face, limbs, and torso, emphasizing the features that protrude or recede into space. Modeling three-dimensional forms in such a manner created a sense of pictorial relief, consistent with sculpture in the round. Comparisons between painting and sculpture reoccurred throughout the early modern era (1400–1700), and especially in the Baroque, as painters deployed spectacular strategies of illumination to emphasize figural relief and the appearance of three-dimensionality. By doing so, they intensified debates about the relative merits of painting's and sculpture's ability to captivate viewers' attention and stir their souls. The two media belonged to a binary system, neither one changing without affecting the other. This was particularly evident in the seventeenth century, where intense rivalries pushed painters and sculptors apart, just as creative collaborations brought them together.

It is in this environment that such painters as Preti revealed their abilities to assimilate the affective powers of both painting and sculpture. He investigated, for example, how colorfully depicted and dramatically illuminated figures could reflect the plasticity (three-dimensionality) of such free-standing sculptures as Gian Lorenzo Bernini's (1598–1680) *St. Longinus in Ecstasy* (fig. 5). Preti's experiments furnished a sharp chiaroscuro that represented boldly depicted figures, thereby enhancing his protagonists' material presence. This is clearly exemplified by his *St. Paul the Hermit* (fig. 3). Like his Caravaggesque predecessors, Preti frequently targeted his audience by employing a representational system that broke with the notion of the self-contained image.[7] St. Paul's body is brilliantly illuminated from the upper left, so much so that the adjacent bible and crucifix, as well as other details,

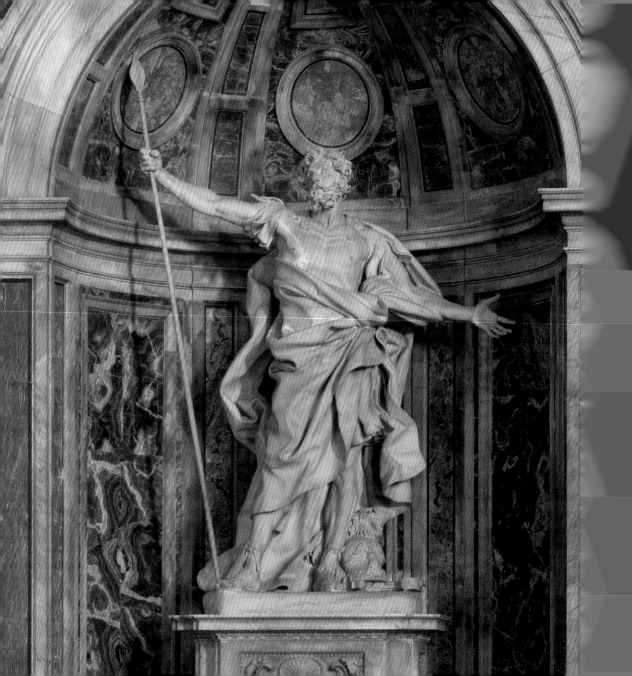

Fig. 5
Gian Lorenzo Bernini,
St. Longinus in Ecstasy,
1638, marble,
St. Peter's Basilica, Rome

Devin Therien

such as the woven mat, are clearly depicted. St. Paul's posture and position before a dark and nondescript background echoes the manner in which niche sculptures appear when the light descends upon them from above. As such, the imposing and illusionistically rendered plastic figure simulates the effects experienced while standing before a life-size sculpture placed within a niche. The saint's boldly designed torso and the deep crevices that appear between the folds in his vestments correspond to the grooves that characterize the robes of Bernini's *St. Longinus*. Here, the light and shade that defines the physicality of Bernini's *St. Longinus* is transformed into a tangible illusion. Before Preti, few had so forcefully combined the plasticity of sculpture with the illusionism of painting.

Preti's achievement is all the more important because it not only fused the color and intense illumination of painting with the concisely incised nature of sculptures, but also provided a pictorial argument for the superiority of painting over sculpture. As such, he illustrated contemporary debates including that outlined by the scientist and philosopher Galileo Galilei while writing to the painter Ludovico Cigoli:

> That sculpture is more than painting
> for the reason that it contains relief and
> painting does not is completely false....
> Those who admire the use of relief in

statues do so, I believe, because they think that by that method they may more easily deceive and appear realistic to us. Now take note of this argument. Painting, like sculpture, makes use of that type of relief which deceives the eye. Painting, in fact, does so more. Besides the light and shade, which produce, so to speak, the visible relief in sculpture, it possesses very realistic colors, which sculpture lacks.[8]

By emphasizing the potent combination of light and shadow with color, Galileo provided a critical textual parallel for painters focused on conveying the relief of their figures through different modes of illumination. The natural philospher's argument applies to a range of pictures that manipulate light as described. Giacinto Brandi's (1621–1691) *The Weeping Heraclitus* (pl. 8), for example, demonstrates how isolated and sharply lit half-length figures also spring forward and create "visible relief" when light and shadow are juxtaposed. Galileo's perspective is centrally important because his conclusion about the superiority of painting resulted from the critical understanding of the phenomenon of light, which he developed through his experiments with telescopes. His assessment was unprecedented in this sense, for it was informed as much

by his scientific work as it was by his knowledge of artistic discourses. Galileo, then, did not bring the same personal critical bias that Mancini did while criticizing painters using a strong chiaroscuro.

LIGHT AND SHADOW III:
ILLUMINATION AS DIVINE SYMBOLISM

Since antiquity, light has been associated with ideas of truth, faith, wisdom, virtue, knowledge, sanctity, and, perhaps most important for the history of Western art, divinity. It then follows that shadows stand for ignorance and faithlessness, if not outright evil. In the bible, light is a symbol of God's presence, his divine favor or protection, and, in the figure of Christ, the one who brought light to the world of man. Given the important role of light in Christian theology, its representation was assured in the history of Western painting, and especially in the Baroque period, as the Catholic Reformation reaffirmed traditional linkages between light and divinity. God's radiance was depicted in scenes of the annunciation of the virgin via supernatural light descending towards the Madonna's torso, and in scenes where saints or Christ himself are depicted with aureoles.

While heavenly light functioned as a metaphor for divine presence in Christian imagery, Baroque artists employed this metaphor in mythological scenes as well. Like Caravaggio's *Conversion of St. Paul* (fig. 6), Preti's *St. Paul the Hermit* demonstrates the particularly Italian focus on the depiction of Christian saints ravished by their engagement with the divine. In both, divine light radiates downwards, brilliantly illuminating the protagonists and provoking dynamic responses. Caravaggio's picture exhibits the supreme power of divine light, as St. Paul forcefully covers his eyes, shielding himself from the mighty ray that compels him to follow in the steps of Christ.

The expression of psychological states and the figural reactions to divine light is central to understanding both paintings.[9] In Preti's picture, the acutely angled light not only dramatically illuminates St. Paul's features, but also conveys the saint's state of mind as his isolated prayer is suddenly interrupted by an awe-inspiring occurrence that captivates his mind, body, and soul. The tone of the light, which is bright and clear, is inconsistent with conventions of heavenly luminescence, as divine illumination was conventionally characterized by a warm, glowing radiance that permeates a scene. Preti's choice of a direct silver light does not mean that he intended to dissociate his subject from its religious significance; rather, it indicates he recognized that whitish lighting against a dark background would create a sense of dramatic surprise that engages the viewer on a psychological level. Preti's representation has much in

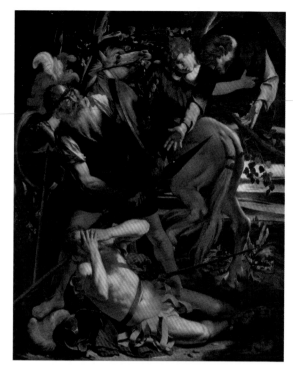

Fig. 6
Caravaggio,
Conversion of St. Paul,
1600–1601
oil on cypress wood,
Odescalchi Balbi
Collection, Rome

common with monumental sculptures, which were similarly designed to provoke deep psychological, and specifically spiritual, experiences. Like Bernini's St. Longinus, St. Paul is captivated by the descending heavenly light. Experimenting with different strategies of illumination was central to achieving such a powerful representation of this experience. Both saints exhibit dramatic facial expressions and physical reactions as their mesmerized eyes and gaping mouths express their awe-struck states. In contrast to the docile characteristics of many Italian Baroque

renderings of saints, Preti's focus on a powerfully lit larger-than-life-size figure emphasises Paul's role as a sacred hero experiencing an impassioned communion with God, who is manifest in the pervasive luminescence and the raven delivering bread.

Divine illumination in mythological scenes followed a similar pattern to that exhibited in religious works. Seventeenth-century painters, for example, transferred the strategies of illumination used for Christ to the Greco-Roman deities. Luca Giordano's (1634–1705) *Massacre of the Children of Niobe* (pl. 1) clearly demonstrates such a practice. Apollo and his twin sister Artemis are depicted at center left, slaying the children of Niobe and Amphion. Like his sister, Apollo's luminescent presence fills the atmosphere as golden light radiates from God himself in Christian scenes. This form of radiance not only indicates Apollo's divinity, but also refers to his personification of the sun, light, truth, and prophecy. It is noteworthy that Niobe, seen on the right grasping one of her children, is depicted as a haggard princess emerging from the darkness that she brought upon herself by questioning Apollo's virility. In Greco-Roman mythology—which Giordano and his contemporaries knew through

such sources as Homer's *Iliad* and Ovid's *Metamorphoses*—the rays that surround and emanate from Apollo carry similar symbolism to Christian metaphors for light.

Giordano's use of light differs from that of Strozzi and Preti. Giordano deploys three different forms of light to both illuminate and illustrate his figures' place in the narrative: the luminescence radiating from the golden aureole around Apollo's head, the yellow beam descending onto the deities from the upper left, and the silver ray illuminating Niobe and her children. By directing different forms of light towards the figures, Giordano emphasizes the golden radiance that is associated with the divine and the pure, while the silver is linked to Niobe's mortality, inferiority, and hubris. The silver light throughout the lower and right half of the composition delineates the figures' torsos, limbs, and facial features by contrasting bright white light with dark backgrounds, in a manner similar to Strozzi's and Preti's. The resulting effects amplify Niobe's worn features, tattered clothing, and hypernaturalistic appearance. The warm illumination, on the other hand, reinforces the delicate, gentle, and graceful appearance of the deities. Apollo's soft features, golden locks, rosy cheeks, and flowing yellow mantle correspond to the similarly idealized qualities exemplified by Reni's Europa. For Giordano, different forms of light clearly communicate the different status, as well as the role and function, of the characters in the overall narrative. At the same time, Giordano endows his figures with different degrees of verisimilitude, as the colors of illumination amplify the characters' idealized or hypernaturalistic appearance. Ultimately, Giordano demonstrates that light, while being used as a metaphor for divinity, also plays a significant role in expressing degrees of verisimilitude.

CONCLUSION

Many early debates regarding the phenomenon of light and its corollary shadow focused on the modes of illumination and how they affected artistic perceptions of verisimilitude. The brief analysis above traces the means by which artists re-created the world by examining the decorum of light, the corporeality of figures created by different means of illumination, and the symbolism of divine luminescence that comprised the representation of natural and divine light in Italian Baroque painting. Future studies must investigate the role and function of artificial sources of illumination—that produced by candles and torches, for example—to further understand how artists enhanced the theatricality of their pictures through the dynamic and mysterious use of light and shadow.

Notes

1. Leonardo da Vinci, *Leonardo on Painting*, ed. Martin Kemp (New Haven, CT, and London: Yale University Press, 2001), 90.

2. Scholars of early modern art (1400–1700) are aware that the nuances of stylistic development, artistic theory, and humanist and aesthetic writings influenced and altered artists' representations of nature from city to city and decade to decade. I refer other readers to Frederick Hartt's excellent and enduring examination of Italian Renaissance art and the ideas and protagonists that shaped it: *History of Italian Renaissance Art, Painting, Sculpture, Architecture*, 7th ed. (Upper Saddle River, NJ: Prentice Hall; London: Pearson Education, 2010).

3. This theory of art, while outlined by such earlier Baroque writers as Giovanni Battista Agucchi (1570–1632), found its most authoritative proponent in the writings of the Roman dilettante, critic, and connoisseur Giovanni Pietro Bellori (1613–1696). Bellori's essay "The Idea of the Painter, Sculptor and Architect" put forth the definitive conceptualization of the idealist theory of art, based as it was on a merger between Renaissance Neoplatonism and art theory and manifest in the art of the great classical painters. For a general summary of Bellori's art theory, see Evelina Borea and Carlo Gasparri, eds., *L'idea del bello: Viaggio per Roma nel Seicento con Giovan Pietro Bellori* (Rome: De Luca, 2000), 7, and Erwin Panofsky, *Idea: A Concept in Art Theory*, trans. Joseph J. S. Peake (Columbia: University of South Carolina Press, 1968).

4. "Specific to this school is the desire to illuminate with a single light that comes from above without any reflections, as it would be in a room with one window with the walls painted black so that, having the lights and the shadows very bright and highly shadowed, they come to give relief to the painting, but however in a un-natural manner not completed nor thought out like those from other centuries or older painters like Raphael, Titian, and Correggio, among others…. This school in their method of working was very observant of nature, so much so that they always had it before them when working. They painted only one figure well, but in the composition of history painting and depicting the emotions, they fail by the imagination and not by the observation of the objects. By depicting nature which they hold before themselves, it seems to me that they do not assess it, being impossible to place in a room, many figures that represent the historical subject with this light from a single window, and having one figure that laughs or weeps or actively moves and remains firm so as to allow it to be copied, and thus their figures, while having force, lack movements, emotions, and grace, which remains in the manner of working as one says. (author's translation)." Giulio Mancini, *Considerazioni sulla pittura*, ed. Adriana Marucchi and Luigi Salerno (Rome: Accademia nazionale dei Lincei, 1956–57), 1:108–9.

5. Ibid.

6. Ibid.

7. For a lengthy discussion of the practice in early modern painting, see Thomas Puttfarken, *The Discovery of Pictorial Composition: Theories of Visual Order in Painting 1400–1800* (New Haven, CT, and London: Yale University Press, 2000), 124, 148.

8. Galileo Galilei, "A Letter Written by Galileo to Cigoli," *Italy and Spain 1600–1750, Sources and Documents*, ed. Robert Enggass and Jonathan Brown (Englewood Cliffs, NJ: Prentice-Hall, 1970), 22.

9. On the expression of psychological and emotional states, see Jennifer Montagu, "The Tradition of Expression in the Visual Arts," *The Expression of the Passions* (New Haven, CT, and London: Yale University Press, 1994), 58–67; Émile Mâle, "La Vision et L'Éctase," *L' art religieux après le Concile de Trente* (Paris: A. Colin, 1932), 151–201.

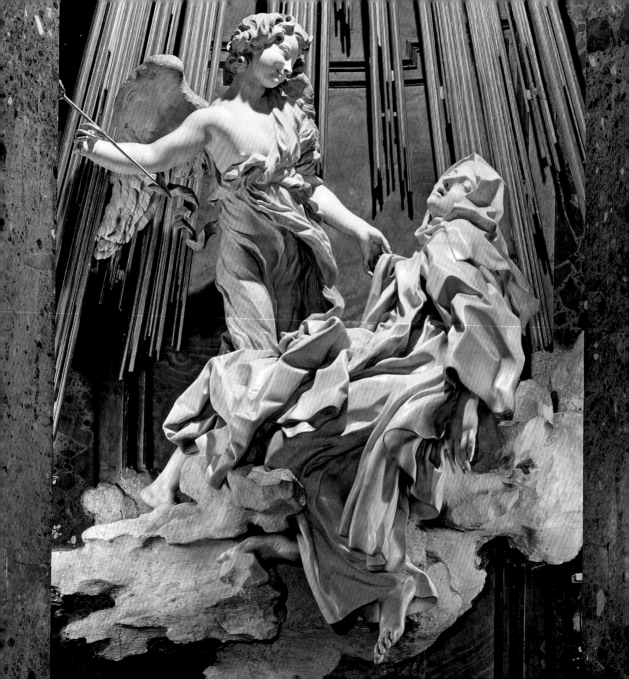

BERNINI, CANADA, AND LIGHT

— C. D. DICKERSON III

Painters were not the only artists of the Italian Baroque who were attracted to the expressive possibilities of light. Gian Lorenzo Bernini (1598–1680), the preeminent sculptor of the seventeenth century, made light one of the dominant themes of his artistry.[1] His sculptures rely on light as no sculptures before them had. The importance he placed on light is particularly apparent when a visitor steps into the Cornaro Chapel in Santa Maria della Vittoria in Rome and lays eyes on his wondrous *St. Teresa in Ecstasy*, a group carved in marble that seems to float over the main altar (fig. 1). Dating to around 1650, it is an essay in illumination.[2] But before it could become that, Bernini had to create its light, which he accomplished in two ways. First, he knew the church's normal lighting conditions were inadequate for viewing the sculpture. It needed light, which he provided by opening a window above it. This is no ordinary skylight, however, in that it is largely hidden from viewers, giving the light that falls on the statue a magical, or divine, quality.[3]

The second way Bernini introduced light was to sculpt it. The beams of real light that descend from the skylight are physically evoked with bundles of gilded wooden rods that spread behind the sculpture and act as a glistening backdrop to it. Here, Bernini uses a combination of tangible light—the rods—and controlled light from the skylight in the service of narration. His interpretation of the subject follows Teresa's own account.[4] She describes how she experienced a vision of a cherub who pierced her heart with an arrow. As the cherub pulled back the arrow, she was lit completely afire with an intense love for God. This is the moment Bernini is intent on portraying. The two kinds of light he introduces—material and immaterial—shower

down on Teresa, symbolizing the divine revelation to which she is suddenly made privy. Meanwhile, the cherub lifts up on her robe, as though drawing her toward the source of the divine light, and we realize her proximity to God is more than suggested: she looks to be levitating on clouds. Light—or rather the absence of light—helps make the illusion work. Through careful engineering, Bernini has given his sculptural group the most minimal of pedestals possible, designing his composition so that the group severely overhangs the pedestal, to the point of needing to be anchored to the back wall to prevent it from toppling forward. But here, too, Bernini evinces a strategic use of modulated light, as the area under the sculpture is cast in shadow, which helps the pedestal to disappear.[5]

Finally, light is for Bernini a material that gives form to the *Teresa*, which can be likened to the way painters approach light. As light filters down on the sculpture from above, the bodies and draperies become legible thanks to the play of light and shadow. Bernini recognized that for Teresa's drapery to look properly agitated, he needed to handle light as if painting with light. To that end, he devised patterns of zigzag folds that are highly legible from afar because of the undercutting beneath the folds. Emphasis is in turn given to the edges, the points where shadow meets light; this, of course, depended on the light being raking, as opposed to uniform on all sides. In some of Bernini's preparatory drawings for the *Teresa*, he appears to be paying particular attention to how raking light can be an agent of form. A study for Teresa's drapery in the Museum der bildenden Künste in Leipzig shows him thinking in terms of shadow and outline, and doing so in the fitting medium of black chalk.[6] Here he is at his most painterly, recognizing that creating the illusion of three dimensions in two is merely a function of light and dark. This awareness could not have come without careful meditation on the world of paintings, with the works of Caravaggio and his followers doubtless among Bernini's primary examples. One painting that helps demonstrate the point is Simon Vouet's *The Fortune-Teller* at the National Gallery of Canada in Ottawa (pl. 3). Vouet has used raking light to model the weighty draperies of the women. The light, which enters the scene from the upper left and front, casts deep shadows behind the folds, which helps give the impression the lit edges represent the projecting parts of the draperies. The sharp spotlight on the figures also has a narrative dimension. It contributes to the dark, foreboding mood that sends signals that we are witness to mischief. This is not unrelated to Bernini's use of light in the *Teresa*: the light from above makes it clear we are somehow observing God's work.

To appreciate the importance Bernini placed on light, a visit to the Cornaro Chapel is one of

many options; St. Peter's Basilica is also replete with good examples, including the *St. Longinus* and the *Celestial Glory*. But to see them involves travel to Rome. Canadians are fortunate to have three sculptures by Bernini within their borders—all on public display—that demonstrate his deep engagement with light. Two belong to the Art Gallery of Ontario in Toronto. The earlier sculpture, in marble, is the bust of Pope Gregory XV, which Bernini probably carved around 1621 or 1627 (fig. 2). The later work is a life-size bronze corpus, or sculpture of Christ on the cross, which was likely cast around 1655 (fig. 3). Both sculptures came to the Art Gallery of Ontario through the munificence of longtime art collectors in Toronto: the marble was given in 1997 by Joey and Toby Tanenbaum; the bronze was a gift of the late Murray Frum. The third Bernini in Canadian collections is a marble bust of Pope Urban VIII (fig. 4), purchased by the National Gallery of Canada in Ottawa in 1974.

The *Urban VIII* in Ottawa is generally recognized as the earlier of two autograph versions of a bust that Bernini carved around 1632.[7] The other version is in the Galleria Nazionale d'Arte Antica in Rome. The bust is likely the one referenced in a letter of 1633 by Bernini's close friend Lelio Guidiccioni, who implies that Bernini had carved a bust of the pope the previous summer.[8] The letter does not explain why Bernini created a second version.

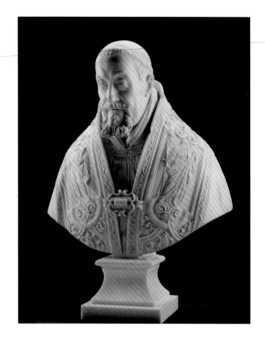

Fig. 2
Bernini, *Bust of Pope Gregory XV*, 1621 or 1627, marble, Art Gallery of Ontario, Toronto

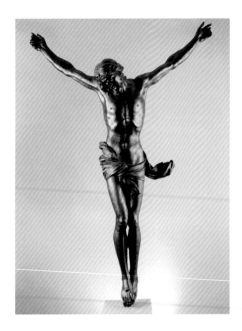

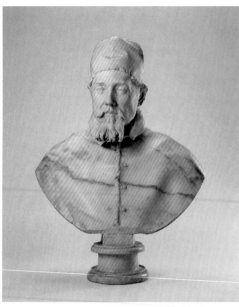

Fig. 3
Bernini,
Crucified Christ,
c. 1655, bronze,
Art Gallery of
Ontario, Toronto

Fig. 4
Bernini,
*Bust of Pope
Urban VIII,*
c. 1632, marble,
National Gallery of
Canada, Ottawa

Speculation has centered on the prominent gray vein running across the cape, which may have been perceived as a flaw and resulted in the order for a new bust. The main problem with the argument is that Bernini would have known about the vein from practically the start of carving; moreover, the vein is hardly a distraction, as it enlivens the cape.[9] The one certainty is that the face is exquisite in execution, a sure work of Bernini, as all scholars acknowledge.

The *Gregory XV* at the Art Gallery of Ontario is newer to scholars, and consensus is still forming over its attribution. I find it to be an exceedingly fine bust—too fine to be the work of an ordinary assis-

tant. Organizers of the recent exhibition "Bernini and the Birth of Baroque Portrait Sculpture," held at the J. Paul Getty Museum in Los Angeles and the National Gallery of Canada in Ottawa in 2008–9, appear to share my view. Although they were disinclined to borrow the bust, they did include it on their checklist of "accepted" works, which is undoubtedly the correct designation.[10] This is not to deny the possibility of workshop involvement, as in the crinkled surplice, which is rendered dryly.[11] But I am hesitant to assign the lion's share of the carving to anyone but Bernini. Lending potential weight to the attribution are unpublished documents found by

Carolyn H. Wood that are reported to indicate that Cardinal Ludovico Ludovisi awarded Bernini a gold chain in 1627 for a marble bust of Gregory XV that was commissioned for the family's palace at Zagarolo.[12] Ludovico was too sophisticated an art patron to have thought Bernini deserving of so luxurious a prize for anything less than a substantially autograph bust. For Bernini's part, he is unlikely to have risked the ire of Ludovico with a weak, workshop copy of a preexisting bust—even if the bust may have been destined for out-of-the-way Zagarolo.

Documents offer a second possibility for the bust. According to a diary entry of November 8, 1622, by a relative of Bernini in Florence, Bernini had made three busts of Gregory XV in metal and marble at the request of Cardinal Ludovisi.[13] One of the three is definitely known, a bronze at the Musée Jacquemart-André in Paris. The second of the three is almost certain to be another bronze, and there are at least three known candidates: at the Carnegie Museum of Art, Pittsburgh; the Museo Civico, Bologna; and the Galleria Doria Pamphilj, Rome. As for the marble, it could be the present bust, which is identical in composition to the bronzes. If so, it may be the marble recorded in the Sala della Fama at the Casino Ludovisi in inventories of 1623 and 1633.[14]

Returning to the theme of light, an important first consideration is that Bernini rarely had the same control over light with busts as he did with sculptures like the *Teresa*, where the location was fixed, and where he could plan for the lighting conditions, even determine them. The notable exception is when he was carving a bust for a tomb or memorial, neither of which describes the *Urban VIII* or the *Gregory XV*. More than likely, he assumed with these busts that he should plan for the even lighting of an interior and not try to anticipate how the light might change over the course of a day. This means he would have treated the busts equally on all sides and not attempted any tricks of visual perception, such as exaggerating the features on one side of the face to compensate for its being in continual shade. Nonetheless, Bernini had a keen sense that when light played over marble, it did play tricks on the viewer's eyes. A famous story credited to Bernini tells how he was intrigued by the notion that if he painted a person's face white, the person becomes unrecognizable, but that his busts, even though carved in the colorless material of marble, are recognizable.[15] He goes on to imply that he knew how to impart color to marble through the careful manipulation of light and shade, while also admitting that the approach sometimes required him to deviate from nature and to adjust facial features in order to achieve the right tonal shifts, or areas of "color." On the *Urban VIII*, among the more wonderful interplays of light and shade—where we sense more soft flesh than obdurate marble—are

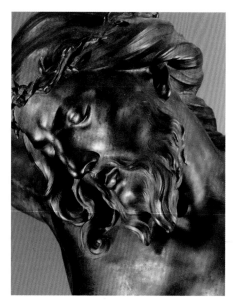

Fig. 5
Bernini, *Crucified Christ*, detail of head and hair, c. 1655, bronze, Art Gallery of Ontario, Toronto

Fig. 6
Bernini, *Cathedra Petri*, 1656–66, gilt bronze, marble, and stucco, Vatican, Rome

on the brow, which is subtly furrowed, and beneath the eyes, where the skin is delicately modulated to suggest the underlying muscles. The eyes themselves also read realistically thanks to Bernini's exploitation of the illusionistic properties of light and shade. According to one description, he had a precise way of carving his irises.[16] After coloring in the parts he thought should be black with chalk, he carved the chalked parts away, knowing they would be replaced with shade. This seems the approach taken with the *Urban VIII*, as well as with the *Gregory XV*, where the pupils are rendered in relief, which makes them look as though light is glinting off them. The entire expression pulsates with life.

The third Bernini in Canada, the *Crucified Christ* at the Art Gallery of Ontario, is also monochromatic. It is cast in bronze, however, not carved in marble, which means it is uniformly the grayish color of the metal. The *Christ* is very similar in form and identical in dimensions to a bronze Christ that Bernini executed for King Philip IV of Spain. Initially, this version was used by the king to adorn the royal mausoleum at the Escorial; it eventually found its way to the sacristy.[17] How to explain the version in Canada, then, and can it be attributed to Bernini? Tomaso Montanari has brought forth a convincing case that the *Christ* is to be identified with one Bernini is recorded as having made for himself and later gifted to his friend Cardinal Sforza

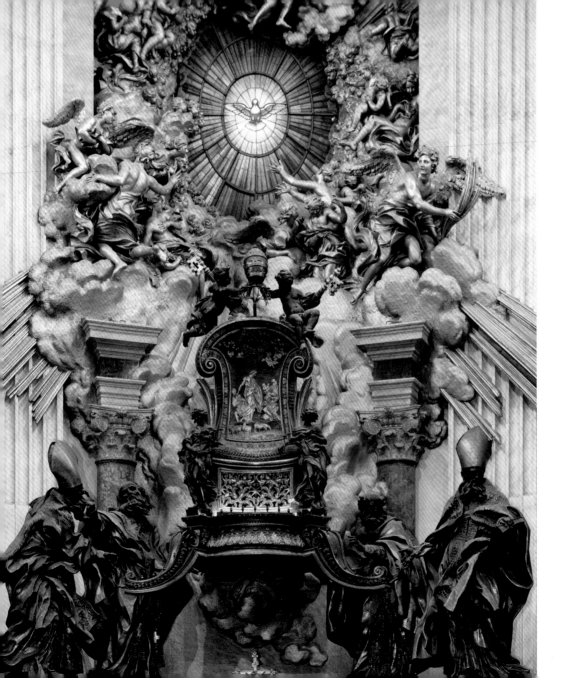

Pallavicini.[18] Montanari is careful to stress that the two *Christ*s are not strict copies of one another—more "brothers than twins." Bernini may have undertaken changes to the Spanish *Christ* to convert it from a dead Christ to one who is still clinging to life, which does seem to describe more accurately the Canadian *Christ*.[19] Beyond the clear relationship between the two *Christ*s, the attribution to Bernini can be substantiated on qualitative grounds. The bronze is expertly finished, with the chasing taken to an even higher level than on the Spanish *Christ*. This does not mean that Bernini necessarily did the chasing himself; he typically relied on specialists in Rome, the best of whom were at his disposal.[20] Rather, the inordinately high quality of the sculpture speaks to this being a project that Bernini supervised minutely. We can be sure he considered the *Christ* autograph, and so should we.

One aspect of the chasing that Bernini must have been very careful to specify to assistants—or that he undertook himself as part of the finishing touches—pertains to the hair and involves light. The individual curls come to sharp ridges that help scatter the light as it plays over them (fig. 5). But there is yet another component to the sparkle: the area between the ridges bears a stippled texture that causes the light to vibrate, rendering the impression that the bronze is not bronze but something softer, like hair. The style of chasing

is also important for the "coloristic" contrast it creates with the smooth flesh of the face. As Bernini seems to have appreciated, the reflective properties of bronze hold immense potential for aesthetic exploitation. Imagine the *Christ* in its most likely setting, above an altar covered with lit candles. The flickering flames would have turned the *Christ* into a shimmering apparition, which could not be more appropriate for the moment being depicted, when Christ leaves his body and ascends. Bernini used bronze throughout his career, with some of his most notable successes coming in St. Peter's, where he knew marble was not the right material on all occasions. In the apse, the bronze *Apostles* who lift the bronze *Cathedra Petri* all had to be in bronze (fig. 6). If in white marble, they would have been lost against the white architecture.[21] Moreover, as Bernini devised, the whole visual conceit of the apse was premised on luminosity—divine luminosity.[22] Among the traditional materials of sculpture, bronze was the king of illumination, which made it the obvious choice for Bernini. Once again, he sculpted with light. His colleagues in painting—including many of the ones represented in this exhibition—must also have appreciated how his approach to light transformed the apse, as it did the *Christ*, into a sculpted painting.

Notes

1. The fundamental study of Bernini and light remains Frank Fehrenbach, "Bernini's Light," *Art History* 28 (2005): 1–42.

2. On the issue of date, see Caterina Napoleone, "Bernini e il cantiere della Cappella Cornaro," "Studi sul Settecento," *Antologia di Belle Arti* 55/58 (1998): 172–86.

3. On the skylight and how the original fall of light on the sculpture was much less than today, see Irving Lavin, *Bernini and the Unity of the Visual Arts* (New York: Oxford University Press for Pierpont Morgan Library, 1980), 1:104.

4. On the iconography, see ibid., 1:127–24.

5. See Fabio Barry, "Sculpture in Painting/Painting in Sculpture: c. 1485–c. 1600," in *On the Meanings of Sculpture in Painting*, ed. Penelope Curtis, exh. cat. (Leeds: Henry Moore Institute, 2009), 18, who claims the *Teresa* was the first "baseless" sculpture.

6. Heinrich Brauer and Rudolf Wittkower, *Die Zeichnungen des Gianlorenzo Bernini* (Berlin: H. Keller, 1931), 2:pl. 24b.

7. Andrea Bacchi, Catherine Hess, and Jennifer Montagu, eds., *Bernini and the Birth of Baroque Portrait Sculpture*, exh. cat. (Los Angeles: J. Paul Getty Museum; Ottawa: National Gallery of Canada, 2008), 135–36, cat. 2.5.

8. Cited in Cesare D'Onofrio, *Roma vista da Roma* (Rome: Liber, 1967), 381–88. See also Philipp Zitzlsperger, *Gianlorenzo Bernini. Die Papst- und Herscherporträts. Zum Verhältnis von Bildnis und Macht* (Munich: Hirmer, 2002), 179–83.

9. As observed by David Franklin in Bacchi, Hess, and Montagu, *Bernini and the Birth of Baroque Portrait Sculpture*, 135.

10. Ibid., 285, no. A7e.

11. On the likelihood Bernini received a "helping hand," see Zitzlsperger, *Gianlorenzo Bernini*, 163.

12. As reported in ibid. The document, to my knowledge, has not been published.

13. As cited in Stanislao Fraschetti, *Il Bernini, la sua vita, la sua opera, il suo tempo* (Milan: U. Hoepli, 1900), 32n1.

14. Carolyn H. Wood, *The Indian Summer of Bolognese Painting: Gregory, 1621–23, and Ludovisi Art Patronage in Rome* (Ph.D. diss., University of North Carolina, Chapel Hill, 1988), 152–53.

15. The story is related by two sources: Nicholas Stone, Jr., and Paul Fréart de Chantelou. For Stone's account, see Walter L. Spiers, "The Notebook and Account Book of Nicholas Stone," *The Walpole Society* 7 (1918), 171. For Chantelou's, see Paul Fréart de Chantelou, *Diary of the Cavaliere Bernini's Visit to France*, ed. Anthony Blunt, annotated by George C. Bauer, trans. Margery Corbett (Princeton, NJ: Princeton University Press, 1985), 16. For a recent and excellent critical interpretation of the story, see Genevieve Warwick, "'The Story of the Man Who Whitened His Face': Bernini, Galileo, and the Science of Relief," *The Seventeenth Century* 29, no. 1 (2014): 1–29.

16. Chantelou, *Diary of the Cavaliere Bernini's Visit to France*, 254.

17. For a recapitulation of the history, see Tomaso Montanari, "Bernini per Bernini: Il secondo 'Crocifisso' monumentale. Con una digressione su Domenico Guidi," *Prospettiva* 136 (2009), 2–3.

18. Ibid.

19. See ibid., 5–6.

20. As discussed by Jennifer Montagu, *Roman Baroque Sculpture: The Industry of Art* (New Haven, CT: Yale University Press, 1989), 48–75. See also Andrea Bacchi, "The Role of Terracotta Models in Bernini's Workshop," in *Bernini: Sculpting in Clay*, by C. D. Dickerson III, Anthony Sigel, and Ian Wardropper, exh. cat. (New York: Metropolitan Museum of Art, 2012), 55–61.

21. Bernini's concern with how the *Cathedra Petri* would appear from afar is evident from a story related by Lione Pascoli, *Vite de' pittori, scultori, ed architetti moderni*, ed. and annotated by Alessandro Marrabotini et al. (2 vols., 1730–36; repr. Perugia, Italy: Electa Editori Umbri, 1992), 75. See also the drawing in Brauer and Wittkower, *Die Zeichnungen des Gianlorenzo Bernini*, 2:pls. 74a–b.

22. Fehrenbach, "Bernini's Light," 20.

FROM ITALY TO HOLLAND: CARAVAGGIO'S DARKNESS AND LIGHT COME NORTH

— LLOYD DeWITT

Baroque art in Italy was a multifaceted movement, encompassing the marvelous dynamism of Bernini's sculpture, the scintillating spectacle of Pietro da Cortona's frescos, and the dramatic light and realism of Caravaggio's canvases. Caravaggio was arguably the most influential Italian artist of the period; his style found proponents throughout Europe, even in Protestant England and Holland. The story of how Caravaggio's style spread to Holland in particular is not a simple one, involving the movement of art across Europe and the movement of young artists from Holland to Rome and back again.

In 1616, Caravaggio's *Madonna of the Rosary* (fig. 1) was listed in the inventory of the Amsterdam art dealer Abraham Vinck along with the now-lost *Judith and Holofernes*, paintings Vinck owned jointly with Louis Finson (1580–1617). They sold the *Rosary* to a consortium led by the renowned

painter Peter Paul Rubens, who acquired it for the Dominican church in Antwerp.[1] Finson himself owned a third painting by Caravaggio and moreover produced his own copies after Caravaggio's works and works in his style.[2] In 1619 the Amsterdam artist Pieter Lastman (1583–1633), who would later be Rembrandt's teacher, appraised another painting by Caravaggio in an Amsterdam collection.[3] By the time Rembrandt (1606–1669) entered his workshop, however, no works by Caravaggio remained in Holland, leaving him to learn about Caravaggio's radical style through copies and imitations. Works by Caravaggio's other followers also found their way north, however. According to Rembrandt's pupil and biographer Joachim von Sandrart, merchant Balthasar Coymans of Amsterdam owned several works by Bartolomeo Manfredi, the Italian artist most closely associated with Caravaggio.[4]

Fig. 1 (detail)

67

Fig. 1
Caravaggio, *Madonna of the Rosary*, c. 1606–7, oil on canvas, Kunsthistorisches Museum, Vienna

One of the great paradoxes of seventeenth-century painting is the role of foreigners in spreading Caravaggio's gripping and dramatic realism throughout Europe. Among his most successful followers in Rome were three artists from Utrecht in the Netherlands: Gerrit van Honthorst (1590–1656), Hendrick ter Brugghen (1588–1629), and Dirck van Baburen (c. 1595–1624). They were not directly trained or directly influenced by Caravaggio; in fact, two of them had not even arrived in Rome until after Caravaggio's departure from that city in 1606.[5] Instead, Van Baburen had met Bartolomeo Manfredi while in Parma. It was through Manfredi that Van Baburen learned to appreciate the use of natural light, in contrast to Van Honthorst's use of candles, torches, and other sources of artificial light in nocturnal scenes.

Additionally, some of Caravaggio's most successful Italian followers were not from Rome either, but rather Naples, where he had also lived. These included Luca Giordano (1634–1705; pls. 1, 2, 6) and Mattia Preti (1613–1699; pl. 4). In contrast, in Rome, where Caravaggio found his greatest success, foreign followers and imitators launched an international art movement that spread to France, Spain, Flanders, and the Netherlands. What Caravaggio's former Roman patrons saw in the works of the three Dutch artists, among scores of Northern artists working in the city at the time, was a sensitive yet original interpretation of Caravaggio's innovative manner.

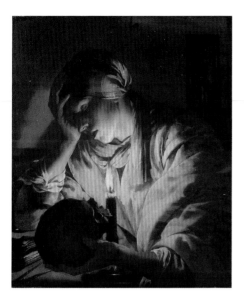

Fig. 2
Hendrick ter Brugghen, *Melancolia*,
c. 1627–28, oil on canvas,
Private Collection, on loan to the Art
Gallery of Ontario, Toronto

The dramatic candlelit *Melancolia* (fig. 2) is the product of Hendrick ter Brugghen, the first of the three to arrive from Utrecht in Rome in 1604. He was thus the only one of the three who could have encountered Caravaggio there. He was followed by Dirck van Baburen, who arrived some time between 1612 and 1615, and Gerrit van Honthorst, who came in 1616. Each quickly assumed the style of Caravaggio, and in the process gained the support of some

of Caravaggio's most influential patrons. Cardinal del Monte, whose help gave Caravaggio the commission for the groundbreaking *Calling of St. Matthew*, acquired a work by Van Honthorst, as did Giustiniani. Van Honthorst became famous for scenes dramatically lit by artificial sources such as candles or torches.[6] Cardinal Scipione Borghese helped Van Honthorst secure important commissions.[7] Van Baburen was aided by the Cardinal Borghese and Giustiniani as well, and obtained an important commission painting the *Entombment* for the chapel of the Pietà in San Pietro in Montorio in 1617.[8]

These three artists were not copyists of Caravaggio's paintings. They adopted his chiaroscuro and at times loosely followed his compositions, but often focused on a single aspect of his subject matter. Van Baburen, for example, concentrated on religious subject matter when he worked in Rome, while Van Honthorst preferred light-hearted, erotically charged tavern and brothel scenes shown at night, almost always featuring artificial sources of light.[9] Van Honthorst painted many single-figure works featuring types familiar from Caravaggio's works. Their paintings have in common a solid, fleshy robustness—evident in *Melancolia*—that is distinct from the more arid manner of Caravaggio himself.

The deep black areas employed by Caravaggio to suggest intense darkness frequently threatened to dematerialize the figures in his works, while the

Fig. 3
Abraham Bloemaert,
Judgment of Paris,
c. 1592, pen and
brown ink and gray
wash over traces of
black chalk on laid
paper, Art Gallery of
Ontario, Toronto

strong raking light he preferred exaggerated the texture of the surfaces.[10] Caravaggio's realism is often enhanced through the apparent randomness of patches of highlights, which the philologist and critic Franciscus Junius the Younger referred to as a "chessboard" effect that gave the works the appearance of spontaneity and spatial ambiguity.[11] Ter Brugghen and his Utrecht compatriots avoided the textured "relief" effect that dominated Caravaggio's own works in favor of strong forms and more unified compositions.[12]

The critic Bellori saw the "truthfulness" of Caravaggio's own highly muted use of color as an unprecedented repudiation of the "prettiness and vanity in colours" of the elegant and highly stylized mannerism refined in late fifteenth-century Florence and that persisted in Utrecht.[13] Like the work of the other former pupils of Abraham Bloemaert (1566–1651) in Rome, Ter Brugghen's style in *Melancolia* bore no trace of the elegantly curving mannerism so evident in his master Bloemaert's 1592 drawing *Judgment of Paris* (fig. 3). Rather, what stayed with

Fig. 4
Abraham Bloemaert,
Madonna and Child,
c. 1628, oil on canvas,
Private Collection,
on loan to the Art Gallery
of Ontario, Toronto

them was the use of more solid figures and brighter colors evident in Bloemaert's later *Madonna and Child* (fig. 4) of c. 1628.

The bright color and softly rendered skin in the child's face are among the few mannerist features that lingered in this otherwise solidly classical late work. It was executed at a time when his pupils working in the manner of Caravaggio were at the height of their influence in Utrecht. This is one of the few surviving examples of a *Madonna and Child* by Bloemaert. The demand for works with tradi-

tional religious subject matter was weak, even in a relatively sympathetic market such as Utrecht, where Catholics retained a measure of influence. A few other versions by Bloemaert were known, including one in the collection of the Protestant Stadhouder Frederik Hendrik.[14]

Mannerism in Holland did not originate in Utrecht but rather in Haarlem, among a group of artists including Karel van Mander (1548–1606), Hendrick Goltzius (1558–1617), and Cornelis Cornelisz. van Haarlem (1562–1638). These, in turn, derived their elegant, contorted style from the works of Bartholomeus Spranger (1546–1611), whose compositions were popularized in the Netherlands through engravings after his works by Goltzius, who had seen his work in Prague, at the court of Rudolf II. Thus a style that had its roots in the works of Michelangelo as interpreted by his Florentine followers had a long afterlife far away in Utrecht. Bloemaert's own mannerism was thus in keeping with the dominant artistic movement of his age.

Utrecht was, however, perhaps the last outpost of this style. Traces of precious artificiality persist in Bloemaert's work for the remainder of his career at the same time his pupils were popularizing their dramatically realistic manner. He was not alone, however, as other Utrecht artists like Joachim Wtewael (1566–1638) and Cornelis van Poelenburg remained even more ardent adherents of later

mannerism, carrying the torch of hyperelegance in their works well into the 1640s, at a time when Rembrandt and Frans Hals had reached maturity.

It was unclear if the allure of antiquity, the Renaissance masters, or the prospect of financial success induced the three Utrecht pupils of Bloemaert to leave the Netherlands and come to Rome between 1604 and 1616. It is also unclear why, among the Dutch émigré artists, primarily Utrecht painters favored Caravaggio's style. Besides Bloemaert's pupils, for example, there was also Mattias Stom (c. 1600–after 1652), who likely came from Amersfoort, nearby Utrecht. He trained with Van Honthorst in Rome, and developed a particularly warm and colorful version of Caravaggio's manner, evident in *Christ and the Woman Taken in Adultery*, c. 1630–33 (pl. 11). Paulus Bor (c. 1601–1669) also hailed from Amersfoort, and worked in Rome in a Caravaggist manner as well, of which only traces remain in later works painted on his return Holland. The chiaroscuro in his *Annunciation of the Death of the Virgin* of c. 1635–40 (not pictured) still faintly recalls his Roman Caravaggesque manner.[15]

Mannerism ironically had a longer life in the Netherlands than did the Caravaggism of the Utrecht painters. This was partly the result of the early demise of two of the three Bloemaert pupils—Hendrick ter Brugghen and Dirck van Baburen—by 1629. The third, Gerrit van Honthorst,

became a successful court portraitist of international repute, working in a dry, classicist style. Caravaggio's influence also persisted in other ways, however, and was, in the end, durable. Rembrandt's powerful chiaroscuro reflects his admiration for Caravaggio and his followers. And Johannes Vermeer's (of Delft, 1632–1675) mother-in-law, Maria Thins, owned works by Van Baburen, which Vermeer reproduced in his own paintings.[16]

The true subject of Ter Brugghen's *Melancholia* remains ambiguous and in the past was at times interpreted as showing St. Mary Magdalene as a penitent. The female subject indeed appears deep in contemplation and holds a skull, though she is missing any of the other attributes of the Magdalene, instead possessing callipers, a symbol of mathematics, identifying her as a personification of melancholia. For the Protestant Ter Brugghen, directly honouring the Magdalene may have proved problematic. Ter Brugghen's *Melancolia* stands in contrast to Louis Finson's copy of Caravaggio's *Magdalene*, in turn copied by Wybrand de Geest of Leeuwarden, who added the symbols of the Magdalene: the ointment jar and skull that Caravaggio had left out.[17]

Ter Brugghen may have chosen to alter the composition for personal reasons. He was apparently not the most outgoing of the Utrecht Caravaggisti. When Gerrit van Honthorst returned to Utrecht from Rome in 1620, the artistic com-

Fig. 5
Hendrick Goudt after
Adam Elsheimer,
*Jupiter and Mercury in
the House of Philemon
and Baucis*, 1612,
engraving, Art Gallery
of Ontario, Toronto.
Purchased with funds
donated by AGO
Members, 1991.
Acq. 91/160

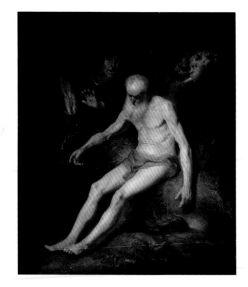

Fig. 6
Jan Lievens, *Job*, 1631, oil on canvas, Gift of the National Art Collections Fund of Great Britain, 1933, National Gallery of Canada, Ottawa
Photo © National Gallery of Canada

munity held a feast in celebration at an inn called Het Poortgen. The lawyer and collector Arnout van Buchel was in attendance, and noted the proceedings in his invaluable diary. While Rubens's work and career were discussed at length, it seems Ter Brugghen was not even in attendance.[18] It seems the theme of melancholy may have been one to which he could have related to quite closely.[19]

Van Honthorst died in 1656; he thus far outlived the other two main Utrecht Caravaggisti, and he also enjoyed the greatest international success. The English collector Thomas Howard, the Earl of Arundel, received Van Honthorst's now-lost *Aeneas Fleeing Troy* as a gift from the ambassador to the Dutch court in The Hague Sir Dudley Carleton. In thanking Carleton, Howard lauded its "postures & ye colouring, I have seene fewe Duch men arrive unto it, for it hath more of ye Italian then the Flemish & much of ye manor of Caravagioes colouring, wch is nowe soe much exteemed in Rome."[20]

The young Rembrandt favored extremes in light and dark, although he never visited Italy and it is not certain he ever saw works by Caravaggio himself. Instead he learned from works of art several steps removed. He based his groundbreaking early *Supper at Emmaus* on a Hendrick Goudt engraving after the Hamburg-born Roman painter Adam Elsheimer's *Jupiter and Mercury in the House of Philemon and Baucis* (fig. 5). Elsheimer's candlelit interior is itself

a clear homage to Caravaggio's revolutionary innovations in chiaroscuro.[21] This made Caravaggio the source of the dramatically lit and naturalistic style Rembrandt developed in concert with Jan Lievens of Leiden around 1626–31, seen in the latter's *Job* (fig. 6). That painting shows faithful and prosperous Job brought low by the calamities Satan has visited on him with the permission of God. Lievens used the popular subject as an opportunity to paint the entire

body of the old man in all its wrinkled glory, a tour de force of realist virtuosity.[22]

The similarities between the elderly figures in Lievens's *Job* and Mattia Preti's later *St. Paul the Hermit* (pl. 4), painted in faraway Naples, are remarkable, and bear witness to the international character of the Caravaggesque movement. Preti's saint is shown being informed by a raven, which miraculously brought him a loaf of bread each day, that a guest would be visiting him. The bird communicated the message by bringing an unprecedented double loaf. The visitor, St. Anthony Abbot, had lived as a hermit in the desert for decades and grown proud of his endurance. As a lesson in humility, he was shown in a dream that he was not alone in his fortitude, and was informed about Paul. This visit breaks Paul's total isolation towards the end of his life. Preti's *St. Paul* is typical of the kind of imagery popular in Italy during the Counter-Reformation, when the church sought to direct attention to its early history. Lievens's choice of an Old Testament figure is, in turn, typical of the kind imagery favored in the Protestant north.

While Lastman was quite familiar with, and even judged a connoisseur of, the work of Caravaggio and his followers, his pupil Rembrandt only knew Caravaggio's style at second hand. Rembrandt absorbed Caravaggio's influence through imported copies, the Caravaggesque works of the Utrecht painters, and also through the work of Jan Lievens,

who was his friend, rival, and fellow Lastman pupil.[23] Unlike the Utrecht Caravaggisti, Rembrandt and Lievens felt no need to visit Italy, telling the Stadhouder's secretary, Constantijn Huygens, that they were too beset by commissions to travel, and besides, the world's best paintings could be seen in Amsterdam.[24] Lievens's early works do betray direct knowledge of Van Honthorst and Ter Brugghen, and he himself may even have stayed in Utrecht, so it was likely he who brought to Leiden the love of dramatic lighting for which Rembrandt is renowned.[25]

Strikingly, both Rembrandt and Caravaggio were criticized for their excessive naturalism, which breached standards of decorum. The Dutch painter and biographer Arnold Houbraken made this connection explicitly in his *Groote Schouburg* (Great Theatre) of 1718: "Our great master Rembrandt was of the same opinion, taking it as a basic rule to follow nature alone, regarding everything else with suspicion."[26] Their conduct in public was subject to comparable criticism: Caravaggio for what the biographer and painter Karel van Mander called excessive "fighting and quarrelling," and Rembrandt because he sought the company of common people rather than elites, saying, "If I want to relieve my spirit, then I should not seek honour, but freedom."[27]

Rembrandt can be regarded, as Margriet van Eikema Hommes notes, as a follower of Caravaggio, albeit a very late one. In late works such as *The*

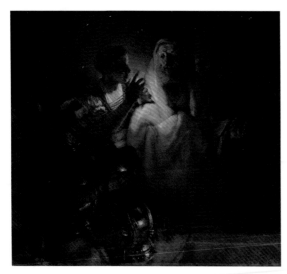

Fig. 7
Rembrandt,
The Denial of Peter,
1660, oil on canvas,
Rijksmuseum, Amsterdam

Instead of Caravaggio's "chessboard" pattern of harsh and apparently random highlights, Rembrandt used what his pupil and biographer Samuel van Hoogstraten referred to as "kindred colours," which he described as follows in his advice: "Let your stronger lights be accompanied gently by lesser lights" to avoid harsh tonal transitions.[29] Rembrandt was also admired for softening the effects of his harsh shadows by using reflections, gradually refining the effects of reflected light and managing complex lighting situations to an astonishing degree of virtuosity, and even deliberately exploiting the reflections of light on the impasto surface of the paint in his works.[30] All this innovation in the use of light and dark is unthinkable, however, without Caravaggio's groundbreaking work.

Caravaggio had a varied and lasting impact on Dutch art in the seventeenth century, despite the fact that he had no Dutch pupils or clients, and never visited Holland. His works, however, did make it that far north. Furthermore, his followers from Utrecht drew on his style and subject matter to create a dramatic and influential new artistic language in Holland. Lastly, his innovations lived on and were refined in the work of Rembrandt and Vermeer. This influence has made Caravaggio, perhaps more than Bernini or Rubens, the standard-bearer of the Baroque in Europe, a status he could have hardly imagined during his own troubled and peripatetic career.

Denial of Peter (fig. 7) he maintains the close-up compositions and half-length figures as well as the dramatic light reminiscent of Caravaggio's style.[28] In Utrecht, Van Honthorst, Van Baburen, and Ter Brugghen blended the mannerism of their teacher Bloemaert with Caravaggism to create a lively new and distinct idiom in Dutch art. In Leiden and Amsterdam, Rembrandt sought to improve on Caravaggio in his own use of light and color.

Notes

1. Natasha Seaman, *The Religious Paintings of Hendrick ter Brugghen* (Farnham, UK: Ashgate, 1988), 53–54.

2. Finson was from Flanders but lived in Amsterdam from 1616 until his death the following year. Seaman, *Religious Paintings*, 53.

3. Ben Broos, "Pieter Lastman," *Grove Dictionary of Art*, 193–94.

4. This was confirmed by the appearance of works by Manfredi listed at the auction of his heirs in the early eighteenth century. See Volker Manuth, "Michelangelo of Caravaggio, Who Does Wondrous Things in Rome," in *Rembrandt Caravaggio*, ed. Duncan Bull, exh. cat. (Amsterdam: Rijksmuseum, 2006), 188.

5. Bob Haak, *The Golden Age: Dutch Painters of the Seventeenth Century* (New York: H. N. Abrams, 1984), 209.

6. Leonard J. Slatkes, "In Caravaggio's Footsteps: A Northern Journey," in *Sinners and Saints, Darkness and Light: Caravaggio and His Dutch and Flemish Followers*, ed. Dennis P. Weller, exh. cat. (Raleigh: North Carolina Museum of Art, 1998), 40–41.

7. Marten Jan Bok, "Artists at Work: Their Lives and Livelihood," in *Painters of Light*, ed. Joaneath Spicer, exh. cat. (Baltimore: Walters Art Museum, 1998), 382.

8. Ibid., 374.

9. Ibid.

10. Margriet van Eikema Hommes, "Light and Colour in Caravaggio and Rembrandt, as Seen through the Eyes of Their Contemporaries," in *Rembrandt Caravaggio*, ed. Duncan Bull, exh. cat. (Amsterdam: Rijksmuseum, 2006), 174.

11. Ibid., 175.

12. Ibid., 171.

13. Ibid., 170.

14. Joaneath Spicer, ed., *Painters of Light*, exh. cat. (Baltimore: Walters Art Museum, 1998), 179.

15. Erika Dolphin, "A Newly Discovered Painting by Paulus Bor for the National Gallery of Canada, Ottawa," *Burlington Magazine* 149 (February 2007): 93.

16. Slatkes, "In Caravaggio's Footsteps," 42.

17. No Ter Brugghen paintings are known to have been painted for the private or clandestine Catholic churches of Utrecht. Seaman, *Religious Paintings*, 77; Manuth, "Michelangelo of Caravaggio," 184.

18. Seaman, *Religious Paintings*, 55.

19. Marten Jan Bok, "Was Hendrick ter Brugghen Melancholic?" *Journal of the Historians of Netherlandish Art* 1, no. 2 (2009), http://www.jhna.org.

20. Manuth, "Michelangelo of Caravaggio," 188.

21. Slatkes, "In Caravaggio's Footsteps," 37.

22. Lievens was probably inspired by a lost Rubens version in Antwerp that he knew through Lucas Vorsterman's 1620 reproductive print. Arthur Wheelock, *Jan Lievens, A Dutch Master Rediscovered*, exh. cat. (Washington, DC: National Gallery of Art, 2008), 130.

23. Manuth, "Michelangelo of Caravaggio," 188.

24. Wheelock, *Jan Lievens*, 287.

25. Slatkes, "In Caravaggio's Footsteps," 41; Wheelock, *Jan Lievens*, 6.

26. Eikema Hommes, "Light and Colour in Caravaggio and Rembrandt," 169.

27. Ibid., 181; Charles Ford, ed. *Lives of Rembrandt: Sandrart, Baldinucci and Houbraken* (London: Pallas Athene, 2007), 92.

28. Eikema Hommes, "Light and Colour in Caravaggio and Rembrandt," 174.

29. Ibid., 175.

30. Ibid., 177, 178.

COLLECTING ITALIAN BAROQUE PAINTING IN CANADA

— DEVIN THERIEN

The history of collecting Italian Baroque painting in Canada is largely due to the fortunes and philanthropy of collectors living in Montreal and Toronto, the early industrial and financial capitals of Canada. As the older and more established of the two centers, Montreal's artists and citizens formed the Art Association of Montreal in 1860—ten years prior to the founding of New York's Metropolitan Museum of Art. By comparison, the National Gallery of Canada was established in 1880, and the Art Museum of Toronto (which became the Art Gallery of Toronto in 1919 and is now the Art Gallery of Ontario) in 1900. Contemporary Canadian and European art dominated the interests of collectors throughout the first fifty years of all three major galleries' existence. However, a small, industrious, and wealthy group of collectors in Montreal, and slightly later in

Toronto, gradually amassed large and diverse collections of Western art spanning the late Renaissance through modern French, British, and Dutch painting and sculpture.[1] By 1880, important collections were being methodically developed by the industrial barons in Montreal. The most influential and notable include Sir William Van Horne (1843–1915), Sir George Drummond (1829–1910), and James Ross (1848–1913). Equally important were financiers, such as Art Gallery of Toronto co-founder Sir Edmund Walker (1848–1924) and industrialist Frank P. Wood (1882–1955), widely recognized as the first significant Toronto-based collector of Baroque painting.[2] These men all shared several important attributes. As financiers and industrialists, they all spent time traveling between and working in Montreal, Toronto, and New York. Through their travels they were exposed

Fig. 3 (detail)

79

to significant Old Master paintings, and their largely Protestant or Anglican work ethic was matched by a voracious passion to collect art, share it with the public, and donate large parts of their time and fortunes to charitable causes.

COLLECTING BAROQUE ART IN CANADA: 1880–1955

Before World War I, Montreal was already recognized as a major center for collecting European art. As the London art dealer David Croal Thomson noted in 1907, Montreal "is the most important artistic center for art of the finest quality" after London, Paris and New York.[3] Thomson continued by stating that "for thirty years and more there have been growing in Montreal collections of pictures which can hold their own with the very best." While Montreal's reputation was largely based on the collections developed by Van Horne, Drummond, and Ross, many other collectors had been actively purchasing paintings in London and installing them in their mansions and estates. This was a significant feat for a country such as Canada, having only become an independent nation in 1867, with a population the tenth the size of its southern neighbor in 1907. Among the early collectors, Van Horne was the most prolific. He amassed nearly four hundred paintings, including works

by the foremost nineteenth-century Romantic and Realist painters. In addition to works by Delacroix, Daumier, and Ribot, he also owned paintings by such Impressionists and Post-Impressionists as Renoir, Cézanne, and Toulouse-Lautrec. One year prior to his death, Van Horne's collection of 230 Old Master and nineteenth-century paintings was valued at $1,235,050 (over 25,500,000 CAD today).[4] Only sixty of the pictures were bequeathed to the Montreal Museum of Fine Arts, as Van Horne's daughter Adaline had inherited only a quarter of the collection. The remainder, which included paintings by Frans Hals, Rembrandt, Ruisdael, El Greco, Francisco de Zurbarán, and Tiepolo, were sold by her nephew in the years after her death. Ross's smaller but significant collection suffered a similar fate, even though, unlike Van Horne, Ross served two terms as president of the museum (1898–1901 and 1911–13). As president, he partly financed the construction of the institution's imposing Beaux-Arts-style building. The new building was opened by the Governor General and His Royal Highness Prince Arthur on December 9, 1912.[5] The opening exhibition included paintings by Rubens, Hals, Rembrandt, Canaletto, and, among others, Delacroix—all lent by Montreal's foremost collectors. The Rubens from Ross's collection, the monumental *Departure of Lot and His Family from Sodom* (c. 1615) was acquired from the London

picture dealer Agnew's in the spring of 1911, and was at that time widely seen as the single most important Old Master painting to grace a Canadian collection.[6] Ross's legacy as a leading supporter of the arts was destroyed by his son's failed business ventures and extravagant spending. John Ross filed for bankruptcy in 1926 and subsequently sold twenty-nine of his father's most prized paintings at Christie's en bloc in July 1927, including the Rubens, which was purchased by the American circus magnate John Ringling.[7]

Similar fates did not befall the collectors and patrons of the fledgling Art Museum of Toronto. Just as Montreal began to lose some of its reputation and irreplaceable pictures, a group of younger collectors established themselves via Toronto's growing financial and industrial activities. In addition to Edmund Walker, renowned for his collection of prints and drawings, several other wealthy Torontonians played a prominent role in developing a taste for Old Master paintings in the city. Foremost among these were Chester Massey (1850–1926) and Reuben Wells Leonard (1860–1930). Along with Walker, these men played a crucial part in building Toronto and Hamilton as important financial and industrial competitors. While collecting in Toronto began later than in Montreal, the climate was established for the city's first major collector of Baroque

paintings and foremost early supporter of the Art Gallery of Ontario to arise: Frank Porter Wood.

By contrast, Ottawa, home to the National Gallery of Canada (NGC), was a small logging town co-opted by the government to serve as the capital, given it was a neutral and unindustrialized town situated between the political and business classes in Toronto and Montreal. Ottawa only grew because of the government presence. As such, the NGC did not have a stable base of collectors it could rely on for patronage. However, the NGC did have access to the public purse, but only in a significant manner after 1913—thirty years after the most important period in the history of North American collecting and museum building. With the exception of such supporters as Edmund Walker and the newspaper baron Harry S. Southam (1875–1954), the current collection of European art was developed by con-secutive directors and curators. This process put the Gallery in good stead until it was forced out of the market by soaring prices and governments unwilling to support art acquisitions.[8] Nonetheless, the NGC successfully acquired many exemplary paintings by Baroque artists, from Guido Reni and Luca Giordano to Bartolome Esteban Murillo, Simon Vouet, and Rembrandt, and it played an integral role in fostering a taste for Italian Baroque art.

PRIVATE COLLECTORS OF BAROQUE ART IN CANADA

Frank Porter Wood

Born in Peterborough, just east of Toronto, Frank Wood was connected to the uppermost echelon of Toronto business circles through hometown friends. The eldest of this group was the banker and Senator George Cox (1840–1914), reputed as the leader of the "Peterborough Methodist Mafia"—a group of Peterborough-born men that dominated business developments in Toronto around the turn of the twentieth century.[9] Wood and his older brother Edward began their careers in Cox's bank, the Central Canada Loan and Savings Company. After a stint in Montreal (1899–1903), Wood returned to Toronto to co-found a highly successful brokerage firm before becoming president of the Burlington Steel Company and vice-president of the Canadian Cartridge Company—a leading munitions manu-facturer during World War I. Wood established his wealth through Burlington Steel. Along with his colleagues at Canadian Cartridge, he returned over $700,000 ($10,000,000 CAD today) of profits to the Imperial Munitions Board.[10] This was the first example of his modest personality and charitable outlook, the benefits of which are most visible in the collections of the Art Gallery of Ontario.

While little is known about Wood's desire to collect art, he had already purchased several Old

Master paintings by the end of the First World War—perhaps at the impetus of Walker, given the latter's promotion of the new gallery. His first known purchase was a late portrait by Frans Hals, which he acquired in New York in 1917. Two years later he purchased from M. Knoedler & Co. Rembrandt's *Portrait of a Lady with a Lap Dog* (c. 1665), a work that held a prominent place in his Toronto home until his death. Like the first generation of Montreal collectors, Wood was particularly interested in high-quality but modest portraits by Northern Baroque painters. His collection was first exhibited at the Art Gallery of Toronto in 1920 and subsequently as part of numerous shows in Toronto, Ottawa, and Montreal. By the 1920s, he was almost exclusively buying paintings from the British art dealer Joseph Duveen. Wood, as such, was the only Canadian of his generation who actively competed with Duveen's major American clients, including Samuel Kress (1863–1955) and Andrew Mellon (1855–1937). Through Duveen, Wood purchased and sold a number of Baroque and Old Master paintings. Foremost among the acquisitions were Hals's portrait of Isaac Abrahamz Massa, Van Dyck's *Daedalus and Icarus*, Goya's portrait of Don Manuel Osorio Manriquede Zuniga, and Gainsborough's *Harvest Wagon*. The Goya was returned to the art dealer in order to acquire the Gainsborough in 1929. Despite offers to purchase pictures by such Italian

Fig. 1
Permanent Exhibition,
1970–99, Fudger Gallery,
Art Gallery of Ontario,
Toronto, 1970; Mattia
Preti's *St. Paul the Hermit*
(plate 4) is the centerpiece
of the room

Renaissance painters as Titian and Lotto—neither being beyond his price point—he continued to buy paintings of secular subjects. Indeed, his interest in such subject matter dramatically influenced Toronto's early collectors as well as the gallery's acquisitions committee.

In addition to serving as an early arbiter of taste, Wood contributed significant funds for the Art Gallery of Toronto's 1926 expansion. Over the next fifteen years, he actively advised the growing gallery and worked as its silent advisor and negotiator with dealers in London and New York. During the 1930s, the collector's taste shifted dramatically as he began to acquire and advise the gallery to purchase works by such Impressionists as Renoir, Monet, Sisley, and Pissarro.[11] Wood's most important contribution came perhaps through his little-publicized fund-raising among, and encouragement of, the city's collectors to purchase and donate works. It was as a result of Wood's activities that Toronto's leading citizens acquired and donated quality pictures by Poussin and, among others, Van Dyck. The bequest of Wood's collection and thirty-acre estate in North Toronto facilitated the creation of the first endowment fund specifically devoted to acquisitions. The most important purchase with this fund was Mattia Preti's altarpiece of *St. Paul the Hermit* (c. 1656; pl. 4), acquired in 1968 (fig. 1). Preti's monumental painting was the pinnacle of nearly twenty years of acquisitions in seventeenth- and eighteenth-century

pictures, purchases that expanded upon Wood's original collection. Notable purchases include works by Tintoretto, Pier Francesco Mola, Eustache Le Sueur, Claude Lorrain, and Giovanni Paolo Panini.

Annie and Horsley Townsend

In addition to Adaline Van Horne's gift in 1941, the most important early contribution to the Montreal Museum of Fine Art's (MMFA) Baroque holdings came through Annie Sofronia White (1875–1949) and her husband George Horsley Townsend's (1866–1954) bequest. Both Annie and Horsley Townsend descended from families in which the visual arts were prized. Horsley Townsend was the great nephew of Jean Bellargé (1726–1805), the prolific Quebecois architect and designer.[12] Like their contemporaries, the Townsends were people of means; they had acquired their fortune through a successful premium wine and spirits importation business. Despite being well traveled, the Townsends kept only a small collection of Canadian paintings, and apparently no European pictures at all.

Following Annie Townsend's death in 1949 and Horsley Townsend's in 1954, all of their cash, stocks, bonds, and personal assets, valued in the millions, were dispersed to various charities, organizations, and family members. The bequest to the Montreal Museum of Fine Arts amounted to $962,000 (over $8,500,000 CAD today)[13] and was composed of considerable securities in, among other significant businesses, Imperial Tobacco, Hiram-Walker & Gooderham-Worts Distillers, British American Oil, and the Bank of Toronto. In section VI of her will, Annie Townsend noted: "The said residual [amount] is to constitute an Endowment the revenues from which are to be used by the said Association [Museum] in purchasing works of art and that the consolidated fund be known as the "Horsley and Annie Townsend Bequest."[14] While the fund was established to purchase all manner of works, the Townsends expressed their desire that "due consideration be given to Canadian artists."[15] Writing to F. Cleveland Morgan (MMFA president) on February 3, 1950, Horsley Townsend communicated the value of the MMFA to the city as follows:

> I […] wish you to know that it has been a real pleasure for me to be helpful to an institution so essential to the cultural life of our City as the Montreal Museum of Fine Arts; and it will be an honor that I shall prize to have my name listed as a Patron of the Museum along with the name of my dear wife, who shared my interest in your work.[16]

The Townsends connection to the MMFA was not as broadly publicized as James Ross's or Adaline

Van Horne's; however, their charitable activities pre-
dated their deaths. Horsley Townsend was recorded
in the 1948 *MMFA Annual Report* as being a "Life
Member." He was given the title of "Patron (Museum
Founder)" after the initial funds were donated by his
wife. The significance of the Townsend bequest was
clearly summarized by Cleveland Morgan:

> Our funds for the purchase of new
> acquisitions had just reached the van-
> ishing point when we received notice of
> a very handsome bequest through the
> Will of the late G. Horsley Townsend
> who has been a Patron and generous
> donor to the Museum for many years.[17]

In the 1956 *Annual Report*, Morgan noted
further that "we can buy at least one really fine
work of art each year, which would not have been
possible without it." The first major purchase with
the funds was Bernardo Strozzi's 1635 *Erosthenes
Instructing Alexandre*, bought in 1959. This acqui-
sition initiated a series of important purchases of
Italian and European Baroque paintings over the
next fifty years, many resulting entirely or in part
from the Townsend fund. In 1960, the Montreal
Museum of Fine Arts purchased Mattia Preti's
1660 *Tobit Blessing Tobias*. Subsequent acquisitions
include Gerrit van Honthorst's *The Duet* (c. 1623)

and *Woman Tuning a Lute* (1624), Jean-François
Millet's *Landscape with Holy Family in Egypt* (1675),
and many other Baroque and Old Master paintings.
In many respects, the losses that followed the deaths
of the first generation of Montreal collectors were
partially recovered through the Townsend's bequest.

Joey and Toby Tanenbaum

Just as Wood played an integral role in building and
funding the Art Gallery of Ontario's acquisitions,
the contributions of more recent benefactors helped
establish the AGO as an institution with premier works
of Baroque art. Joey and Toby Tanenbaum played
a leading role as benefactors of the Department of
European Art throughout the 1980s and 1990s. Neither
of the Tanenbaums grew up in families that promoted
the arts. Their inspiration resulted, instead, from their
parents' rejection of pictures on religious grounds.[18]
The Tanenbaum family, like Wood's, prospered
through the extensive growth of steel production
and industrial financing in the greater Toronto and
Hamilton area in the years preceding and following
the First and Second World Wars. Initially collectors
of French nineteenth-century Realist and Academic
pictures, the Tanenbaums began to acquire Northern
and Southern late-Renaissance and Baroque art during
the 1980s. The couple purchased numerous high
quality pictures by the Italian painter Luca Giordano
and a portrait bust by the great Gian Lorenzo Bernini,

as well as works by the Spanish painters Jusepe de Ribera and Esteban Márquez. At the same time, they acquired three monumental canvases by the Flemish painter Gaspar de Crayer—the most important reinterpreter of Rubens's style—including the massive *Saint Benedict Receiving Totila, King of the Ostrogoths*, executed for the refectory of the Abbey of Saints Peter and Paul in Affligem, Belgium. Ribera's *St. Jerome* (quite possibly the painter's first work), Bernini's *Pope Gregory XV* (fig. 2, p.59), Giordano's *Astronomy* (pl. 6), and De Crayer's *Saint Benedict* significantly enhanced the AGO's Baroque holdings. Along with Wood's pictures, the Tanenbaums' gifts form the bedrock of the European Baroque collection. The different subject matters, countries of origin, and scales distinguish the Tanenbaum and Wood bequests. The Tanenbaums' taste ran towards monumental works produced by artists working in Catholic artistic centers. Wood, alternatively, focused on portraits and small-scale depictions of non-religious subjects by Northern Baroque painters. The great benefit to the AGO is that the collectors' different tastes endowed the gallery with the diversity needed to communicate the broader nature of pan-European Baroque painting.

Recently, the Art Gallery of Hamilton (AGH) was the recipient of the Tanenbaums' comprehensive collection of nineteenth-century art. The bequest also included several Italian Baroque paintings, including one of the most impressive paintings by Giordano in any North American collection. The painter's monumental *Massacre of the Children of Niobe* (pl. 1) exhibits his unique ability to depict dynamic action and heightened emotional states with colorful and fluid brushwork. The resulting picture conveys a mystical quality that is paralleled by the Tanenbaums' three monumental pictures by Gustave Doré gifted to the AGH: *The Triumph of Christianity over Paganism*, *The Dream of Claudia Procula*, and *The Monk's Dream*. Highly dramatic depictions and naturalistic figures link a number of the Tanenbaums' Baroque and nineteenth-century pictures and make them unique contributions to the AGO and AGH.

Michal and Renata Hornstein

Unlike Frank P. Wood, the Townsends, and the Tanenbaums, the Hornsteins' passion for art comes from a passion for life. Both Michal and Renata Hornstein were born to middle-class families in pre-war Poland. Michal Hornstein escaped the Nazis by jumping from a train several hours before his scheduled arrival at Auschwitz. The couple first met while hiding in Hungary. After the war they were reunited by mere chance in Rome and subsequently married in the Eternal City.[19] Michal Hornstein has noted that his wife inspired his interests in art, following her many visits to the Borghese Gallery in Rome. After immigrating to Montreal in 1951, the couple, like many fellow Montreal and Toronto collectors, prospered through

the construction and real estate development that followed the Second World War. While neither grew up in artistic families, the couple's growing passion for collecting blossomed into a serious activity in the 1960s. Their Roman experience dramatically influenced their tastes, and by the 1970s they emerged as serious collectors of sixteenth-, seventeenth-, and eighteenth-century Dutch, Flemish, and Italian paintings. They have become the Montreal Museum of Fine Art's most generous benefactors, purchasing and donating many Baroque pictures. Some of those include Valentin's *King David with a Harp* (c. 1627), Pieter Van Mol's *Deposition* (1630), Matthias Stom's *Christ and the Woman Taken in Adultery* (c. 1630–33; pl. 11), Barent Frabritius's *St. Matthew and the Angel* (1656), and Jan Steen's *The Return of the Prodigal Son* (c. 1668), in addition to many others that will enter the MMFA's European collection in 2016.

While summarizing their interests, Michal Hornstein noted that they collect what they like and what is not in vogue. "It has to be good art and it has to be in good condition."[20] Despite their wide-ranging interests—spanning from Renaissance to Impressionist art—the couple have always returned to Dutch Baroque painting. The breadth of their interests, while partially revealed by their past bequests, will be fully exhibited in 2016 when their entire collection is transferred to the museum. This gift fulfills one of the Hornsteins' most cherished beliefs. In a 1999 speech to the President's Circle at the MMFA, Michal Hornstein stated:

> The greatest part of collecting is giving. Why do I give? I have been living in Montreal and I made my success in the city. I was involved with the Museum for

Fig. 2
"European Masters from Public and Private Collections, Toronto, Montreal, and Ottawa" exhibition, French, Italian, Spanish Renaissance, and Baroque Room, Montreal Museum of Fine Arts, 1954

so long in various capacities that I feel that this institution should be supported. The Museum will get Canadian art from the people that collect it. Old Masters' works are not readily available…. As a collector of these, it is my great pleasure to contribute works to the Museum [because the] things that I cherish are also cared for. The purpose of the art museum is to preserve, exhibit, teach and communicate to the public.[21]

In this sense, Michal and Renata Hornstein's pleasure in collecting, donating, and exhibiting their collection is similar to the Tanenbaums'. As Joey Tanenbaum once expressed, "we get such joy from seeing other people sharing our joy."[22] Like the Thomson Collection at the Art Gallery of Ontario, the Hornstein Collection is the single most important gift to the MMFA by any Montreal or Canadian collector. In a further testament to the Hornsteins' generosity, their paintings, prints, and drawings will be installed in the museum's existing exhibition spaces and not in a single separate space—thereby allowing their gifts to seamlessly enhance the MMFA as a whole. This is an unorthodox approach for bequests of this nature and truly reflects the Hornsteins' desire to have the museum and its visitors benefit from the redesigned Old Master galleries.

EXHIBITING BAROQUE PAINTING IN CANADA (1900–2015)

In the over-one-hundred-year history of the Montreal Museum of Fine Arts, the National Gallery of Canada, and the Art Gallery of Ontario and their acquisition of Italian, French, Flemish, and Dutch Baroque paintings, the first major exhibitions of seventeenth-century art did not occur until the 1980s. Prior to this, galleries relied on or purchased collective shows, exhibiting, for example, the jewels of their collections as a whole, as in the 1954 "European Masters from Public and Private Collections, Toronto, Montreal, and Ottawa" (fig. 2).[23] This was

the first multi-venue exhibition to highlight Renaissance through Post-Impressionist paintings in the MMFA's, NGC's, and AGO's collections. Showcasing seventy-eight paintings from Titian and Tintoretto to Renoir and Van Gogh, the exhibition was positively reviewed as an important example of how the Canadian public should be more optimistic about their global standing, given the world-class pictures in their public collections.[24] A similar but much more ambitious show focusing on leading Baroque and Rococo painters in France was developed by Martin Baldwin (AGO director) and Evan Turner (MMFA director) in 1961 (fig. 3). "The Heritage of France," however, opened to a public that apparently had little taste for such pictures, as exemplified by poor attendance and such scathing critiques as: "if this is what art in France was like at that time thank heaven Quebec was freed from French rule."[25] Perhaps such melodramatic reviews were necessary if curators were to build an interest in Baroque painting in France and Italy among the Protestant Canadian audiences that dominated the nation's largest cities.

A new and ongoing cycle of large Italian Baroque shows followed new acquisitions by the MMFA, NGC, and AGO between 1950 and 1990, as well as through the work of such entrepreneurial curators as Catherine Johnson (NGC), David McTavish (AGO), and David Franklin (NGC). Under their guidance, numerous major Italian Baroque exhibitions were organized in the 1980s, 1990s, and 2000s, including such major achievements as Johnson's "Vatican Splendor: Masterpieces of Baroque Art" (1986) and Franklin's "Bernini and the Birth of Baroque Portrait Sculpture" (2008) and "Caravaggio and His Followers in Rome" (2011). "Vatican Splendor" brought the most important early Baroque paintings from the Pinacoteca Vaticana to Canada, including such renowned altarpieces as Domenichino's *Last Communion of St. Jerome* (fig. 4). These were remarkable achievements, given that the only recorded Italian Baroque painting exhibition included a single picture and was mounted at the MMFA and NGC in December and January of 1937. The dynamic and hyperrealistic *Crucifixion of St. Andrew* by Luca Giordano (purchased as a Jusepe de Ribera) was acquired by J. W. McConnell, the Montreal philanthropist, from the Duke of Rutland in 1937.[26] It was one of the first major Italian Baroque canvases to enter the NGC's collection. Its prominent place instigated subsequent Italian purchases, including exemplary works by Annibale Carracci, Orazio Gentileschi, and Guercino. Not a single show followed its acquisition, however. Instead, the major Canadian galleries continued to produce a diet of conventional exhibitions, notably the 1939 "Seventeenth Century Dutch Painting from the Redelmeier Collection" at the AGO and the 1964 "Canaletto" at the MMFA, NGC, and AGO. The production of the first real Italian Baroque shows may be linked to the influx and

maturation of Italian, French, and Iberian immigrants in Canada following World War II. At the same time, the influence of Walter Vitzthum and Giuseppe Scavizzi—both renowned Italian Baroque specialists—can still be felt in the Art History departments at the University of Toronto and Queen's University. It is worth recalling that the first generation of Canadian curators of European art, including Johnson and McTavish, studied with Vitzthum and Scavizzi at the University of Toronto in the 1950s and 1960s.

CONCLUSIONS

This short history of collecting has revealed several themes that are consistent among many collectors but specific to the most prolific Canadians. First, our collections of Italian Baroque art have grown through a broader interest in European and specifically Dutch and Flemish painting. While more recent collectors have their particular reasons, early interests in Northern European art can be attributed to the early protagonists' familiarity with British collectors—the arbiters of taste for our founders. Second, the most important Italian contributions to the leading galleries came through the combination of gifting and strategic acquisitions. For a country of its size, Canada is unique in owning two important papal portrait busts and a life-size crucified Christ by Gian Lorenzo Bernini, the vast majority of whose

works remain in Italy. The history of collecting Old Master paintings in Canada has grown enough that systematic assessments of past and current collectors need to be conducted in order to better understand some of the basic themes that distinguish them. In so doing, comprehensive studies can be produced that further explain how personal history, aesthetic growth, and contextual factors influence collectors and the works they acquire.

Fig. 4
"Ladies Viewing Domenichino's *Last Communion of St. Jerome*"; "Vatican Splendour" exhibition, Art Gallery of Ontario, Toronto

Notes

1. Evan H. Turner, *Canada Collects, 1860–1960* (Montreal: Montreal Museum of Fine Arts, 1960), 11–16.
2. David McTavish, "From Rembrandt to Renoir in Toronto," in *The Private Collector and the Public Institution*, ed. Sheila D. Campbell (Toronto: University of Toronto Art Center, 1998), 12–31.
3. D. Croal Thomson, "The Brothers Maris," in *The Studio*, ed. Charles Holme (London: The Studio, 1907), XXIX.
4. Janet M. Brooke, "Collecting in Montreal 1880–1920: Modern Art Viewed at Century's End," in *Discerning Tastes: Montréal Collectors 1880–1920*, ed. J. Brooke (Montreal: Montreal Museum of Fine Arts, 1989), 23. This sum was determined by the Bank of Canada's Currency Inflation Rates Calculator. It does not reflect the real value of the works, as set by the art market. As a whole, the collection would likely be worth double that today.
5. Georges-Hébert Germain, *A City's Museum: A History of the Montréal Museum of Fine Arts* (Montreal: Montreal Museum of Fine Arts, 2007), 56.
6. For a comprehensive study of the picture and its provenance, see Virginia Brilliant's *Triumph and Taste: Peter Paul Rubens at the Ringling Museum of Art* (London: Scala; Sarasota, FL: John and Mable Ringling Museum of Art, The State Art Museum of Florida, Florida State University, 2011), 125. The late Kenneth Thomson's (1923–2006) acquisition of Rubens's c. 1611–12 *Massacre of the Innocents* ($55^{15}/_{16} \times 71^{11}/_{16}$ in. [142 x 182 cm]) in 2002 was the only purchase by a Canadian collector that has in part remedied the loss of Ross's painting, which would have undoubtedly been donated to the MMFA. The *Massacre* is the centerpiece of the Thomson Collection and was donated to the AGO in 2005.
7. Turner, *Canada Collects*; Brooke, "Collecting in Montreal." If it were auctioned today, the Rubens would be valued at a minimum $60,000,000 USD. In addition to Ringling, Alvin Fuller, then governor of Massachusetts, purchased Ross's large *Portrait of a Man* by Rembrandt and *Dogana and Salute* by Turner (currently in the Fuller Foundation collection, Boston).
8. See Jean Sutherland Boggs's *The National Gallery of Canada* (London: Thames and Hudson, 1971) for a comprehensive history of its most prolific period of acquisition (1925–75).
9. Michael Bliss, "Better and Purer: The Peterborough Methodist Mafia and the Renaissance of Toronto," in *Toronto Remembered: A Celebration of the City*, ed. William Kilbourn (Toronto: Stoddart, 1984), 194–205.
10. McTavish, "From Rembrandt to Renoir in Toronto," 16. The sum was determined by the Bank of Canada's Currency Inflation Rate Calculator.
11. Ibid., 23.
12. Elaine Tolmatch, "The Enduring Legacy of Horsley and Annie Townsend," *Collage: Le Revue des Amis du Musée des Beaux-Arts de Montréal*, no. 2 (2004): 22.
13. According to the Bank of Canada currency inflation rates.
14. Townsend Bequest, "Will and Last Testament of Anne Sofronia White," p. 5, Montreal Museum of Fine Arts.
15. Townsend Bequest, "*Correspondence* [F. Cleveland Morgan (President) to Horsley Townsend]," February 3, 1950.
16. Townsend Bequest, "*Correspondence* [Horsley Townsend to F. Cleveland Morgan (President)]," February 3, 1950.
17. *MMFA Annual Bulletin* (Montreal: Montreal Museum of Fine Arts, 1955), 5.
18. Alison McQueen, "A Couple's Passion: The Joey and Toby Tanenbaum Art Collection," in *Heaven and Earth Unveiled: European Treasures from the Tanenbaum Collection*, ed. Patrick Shaw Cable, exh. cat. (Hamilton Ontario, Canada: Art Gallery of Hamilton, 2005), 192.
19. Georges-Hébert Germain, "A Free-Thinking Man," *A City's Museum*, 164.
20. Nathalie Bondil, *All for Art: In Conversation with Collectors* (Montreal: Montreal Museum of Fine Arts, 2007), 34.
21. Michal Hornstein, "Collecting Art" (speech to President's Circle, Montreal Museum of Fine Arts, September 30, 1999).
22. McQueen, "A Couple's Passion," 191.
23. On the gallery's early exhibitions, see Karen McKenzie and Larry Pfaff, *The Art Gallery of Ontario: Sixty Years of Exhibitions, 1906–1966* (Toronto: Art Gallery of Ontario, 1980).
24. C. Keiselberger, "A Unique Exhibition, 78 Paintings of European Old Masters at the National Gallery," *The Ottawa Citizen*, March 11, 1954.
25. L. Sabbath, "Indigestible Heritage of France," *Saturday Night Magazine* (Toronto), December 9, 1961.
26. "National Gallery Will Have Ribera," *Montreal Gazette*, December 23, 1937.

SELECTED BIBLIOGRAPHY

Avery, Charles. *Bernini: Genius of the Baroque*. New York: Thames and Hudson, 2006.

Bacchi, Andrea, Catherine Hess, and Jennifer Montagu, eds. *Bernini and the Birth of Baroque Portrait Sculpture*. Los Angeles: J. Paul Getty Museum; Ottawa: National Gallery of Canada, 2008. Exhibition catalogue.

Bok, Marten Jan. "Artists at Work: Their Lives and Livelihood." In *Masters of Light*, edited by Joaneath A. Spicer, 86–99. Baltimore: Walters Art Museum; San Francisco: Fine Arts Museums of San Francisco, 1998. Exhibition catalogue.

Borea, Evelina, and Carlo Gasparri, eds. *L'idea del bello: Viaggio per Roma nel Seicento con Giovan Pietro Bellori*. Rome: De Luca, 2000.

Brooke, Janet M. *Discerning Tastes: Montréal Collectors 1880–1920*. Montreal: Montreal Museum of Fine Arts, 1989. Exhibition catalogue.

Da Vinci, Leonardo. *Leonardo on Painting*, edited by Martin Kemp. New Haven, CT: Yale University Press, 2001.

Eikema Hommes, Magriet van. "Light and Colour in Caravaggio and Rembrandt, as Seen through the Eyes of Their Contemporaries." In *Rembrandt Caravaggio*, edited by Duncan Bull, 164–79. Amsterdam: Rijksmuseum, 2006. Exhibition catalogue.

Enggass, Robert, and Jonathan Brown, eds. *Italy and Spain 1600–1750, Sources and Documents*. Englewood Cliffs, NJ: Prentice-Hall, 1970.

Germain, Georges-Hébert. *A City's Museum: A History of the Montréal Museum of Fine Arts*. Montreal: Montreal Museum of Fine Arts, 2007.

Mancini, Giulio. *Considerazioni sulla pittura*. Edited by Adriana Marucchi and Luigi Salerno. 2 vols. Rome: Accademia nazionale dei Lincei, 1956–57.

Manuth, Volker. "Michelangelo of Caravaggio, Who Does Wondrous Things in Rome." In *Rembrandt Caravaggio*, edited by Duncan Bull, 180–94. Amsterdam: Rijksmuseum, 2006. Exhibition catalogue.

McQueen, Alison. "A Couple's Passion: The Joey and Toby Tanenbaum Art Collection." In *Heaven and Earth Unveiled: European Treasures from the Tanenbaum Collection*, edited by Patrick Shaw Cable. Hamilton, Ontario, Canada: Art Gallery of Hamilton, 2005. Exhibition catalogue.

McTavish, David. "From Rembrandt to Renoir in Toronto: Frank P. Wood's Role as Private Collector, Public Advisor and Munificent Patron." In *The Private Collector and the Public Institution*, edited by Sheila D. Campbell, 12–31. Toronto: University of Toronto Art Center, 1998.

Montagu, Jennifer. "The Tradition of Expression in the Visual Arts." *The Expression of the Passions*, pp. 58–67. New Haven, CT, and London: Yale University Press, 1994.

Seaman, Natasha. *The Religious Paintings of Hendrick ter Brugghen*. Farnham, UK: Ashgate, 1988.

Slatkes, Leonard J. "In Caravaggio's Footsteps: A Northern Journey." In *Sinners and Saints, Darkness and Light: Caravaggio and His Dutch and Flemish Followers*, edited by Dennis P. Weller, 35–46. Raleigh, NC: North Carolina Museum of Art, 1998. Exhibition catalogue.

APPENDIX: ITALIAN BAROQUE PAINTINGS IN CANADIAN MUSEUM COLLECTIONS

Agnes Etherington Art Centre, Queen's University, Kingston, Ontario

Anonymous (17th century), *The Penitent St. Peter*, c. 1630s, oil on paper, 11 ³/₁₆ x 7 ¹⁵/₁₆ in. (28.5 x 20.2 cm), Gift of Alfred and Isabel Bader.

Anonymous Italian artist (17th century), after Lorenzo Lotto, *A Goldsmith Seen from Three Sides*, c. 1628, oil on canvas, 24 x 28 ⁵/₁₆ in. (61 x 72 cm), Gift of Alfred and Isabel Bader, 1986.

Antonio Bellucci (Attr.), *Cimon and Pero (Roman Charity)*, c. 1680, oil on canvas, 23 ⁷/₈ x 29 ⁹/₁₆ in. (60.6 x 75 cm), Gift of Alfred and Isabel Bader.

Felice Fortunato Biggi (Attr.), *Still Life with Flowers*, c. 1675–1700, oil on canvas, 13 ¹⁵/₁₆ x 40 ¹/₈ in. (35.5 x 101.9 cm), Gift of Alfred and Isabel Bader, 1987.

Giacinto Brandi, *The Weeping Heraclitus*, c. 1690, oil on canvas, 47 x 36 ¹/₁₆ in. (119.4 x 91.5 cm), Gift of Alfred and Isabel Bader, 1991.

Antonio Carneo (Attr.), *Samson and Delilah*, c. 1675, oil on canvas, 45 ¹¹/₁₆ x 37 ⁹/₁₆ in. (116 x 95.4 cm), Gift of Alfred and Isabel Bader.

Francesco Cozza (Attr.) and Jan Linsen, *Hagar and the Angel*, c. 1625–50, oil on canvas, 41 ¹/₂ x 52 ¹/₄ in. (105.4 x 132.7 cm), Gift of Alfred and Isabel Bader.

Ciro Ferri, *Joseph Turning Away from Potiphar's Wife*, c. 1675, oil on canvas, 29 ³/₄ x 41 in. (75.6 x 104.1 cm), Gift of Alfred and Isabel Bader, 1971.

Luca Giordano, *Jacob's Dream*, c. 1694–1700, oil on canvas, 29 ¹/₂ x 60 in. (74.9 x 152.4 cm), Gift of Alfred and Isabel Bader, 1988.

Andrea Lanzani, *The Blind Belisarius*, c. 1695, oil on canvas, 51 ¹⁵/₁₆ x 66 ¹⁵/₁₆ in. (132 x 170.1 cm), Gift of Alfred and Isabel Bader, 1971.

Francesco Maffei (Attr.), *The High Priest Aaron Holding a Censer and a Book*, c. 1657–60, oil on canvas, 30 x 26 ¹/₁₆ in. (76.2 x 66.2 cm), Gift of Alfred and Isabel Bader.

Cristoforo Savolini, *St. Peter*, c. 1670, oil on canvas, 47 ¹³/₁₆ x 39 ⁹/₁₆ in. (121.5 x 100.5 cm), Gift of Alfred and Isabel Bader, 1980.

Alessandro Turchi, *Lot and His Daughters*, c. 1620, oil on canvas, 38 ¹³/₁₆ x 52 ³/₄ in. (98.5 x 134 cm), Gift of Alfred and Isabel Bader, 1974.

Filippo Vitale, *The Blessing of St. Blaise*, c. 1618, oil on canvas, 52 x 41 in. (132.1 x 104.1 cm), Gift of Alfred and Isabel Bader.

Art Gallery of Hamilton, Ontario

Luca Giordano, *Massacre of the Children of Niobe*, c. 1685, oil on canvas, 68 ¹⁵/₁₆ x 101 ¹⁵/₁₆ in. (175 x 259 cm), The Joey and Toby Tanenbaum Collection, 2002.

Luca Giordano, *Suicide of Cato*, c. 1660, oil on canvas, 49 x 38 ¹/₄ in. (124.5 x 97.2 cm), The Joey and Toby Tanenbaum Collection, 2000.

Art Gallery of Ontario, Toronto

Pier Francesco Cittadini, *Pietro Bombarda and His Son Antonio*, no date, oil on canvas, 52 ¹⁵/₁₆ x 51 ¹³/₁₆ in. (134.5 x 131.5 cm).

Luca Giordano, *Astronomy*, c. 1653–54 or 1680–92?, oil on canvas, 50 ³/₁₆ x 39 ³/₁₆ in. (127.5 x 99.5 cm), Gift of Joey and Toby Tanenbaum, 1995.

Luca Giordano, *Bacchus and Ariadne*, c. 1685, oil on glass, 23 ³/₁₆ x 31 ¹/₁₆ in. (59 x 79 cm), on loan from a private collection.

Luca Giordano, *Christ before Pilot*, c. 1692, oil on canvas, 37 x 76 ³/₄ in. (94 x 194 cm), on loan from a private collection.

Luca Giordano, *Crucifixion of Saint Andrew*, c. 1660, oil on canvas, 70 ¹¹/₁₆ x 50 ⁹/₁₆ in. (179.5 x 128.5 cm), Gift of Joey and Toby Tanenbaum, 1995.

Luca Giordano, *Minerva Fighting the Giants*, c. 1692, oil on canvas, 87 ⁷/₁₆ x 101 ³/₄ in. (222 x 258.5 cm), Gift of Dr. and Mrs. Gilbert Bagnani, 1988.

Luca Giordano, *The Toilet of Venus*, c. 1663, oil on canvas, 77 ³/₁₆ x 97 ¹/₄ in. (196 x 247 cm), Gift from the family of Max Tanenbaum in his memory, 1991.

Luca Giordano, *Venus and Mars*, c. 1675–80, oil on glass, 23 ³/₁₆ x 31 ¹/₁₆ in. (59 x 79 cm), on loan from a private collection

Giovanni Battista Langetti, *Isaac Blessing Jacob*, date unknown, 50 x 66 ³/₄ in. (127 x 169.5 cm), Gift of Miss L. Aileen Larkin, 1961.

Pier Francesco Mola, *Boy with a Dove*, c. 1652–56, oil on canvas, 38 ¹⁵/₁₆ x 29 ⁹/₁₆ in. (99 x 75 cm).

Nicolas Poussin, *Venus, Mother of Aeneas, Presenting Him with Arms Forged by Vulcan*, c. 1636–37, oil on canvas, 42 ¹/₂ x 53 in. (108 x 134.6 cm), Purchase, 1948.

Mattia Preti, *St. Paul the Hermit*, c. 1656, oil on canvas, 92 x 71 ¹/₄ in. (233.7 x 181 cm), Purchase, Frank P. Wood Endowment, 1968.

Mattia Preti, *Tribute Money*, c. 1655–65, oil on canvas, 62 x 55 ¹/₈ in. (157.5 x 140 cm), Gift of Dr. and Mrs. Gilbert Bagnani, 1988.

Guido Reni, *Christ Crowned with Thorns*, c. 1622, oil on canvas, 25 ⁹/₁₆ x 19 ⁵/₁₆ in. (65 x 49 cm), Gift of Margaret and Ian Ross in memory of Lance, 1990.

Jusepe de Ribera (Attr.), *The Death of Seneca*, c. 1630–56, oil on canvas, 63 ¹⁵/₁₆ x 59 ¹/₁₆ in. (162.5 x 150 cm).

Jusepe de Ribera, *St. Jerome*, c. 1610–13, oil on canvas, 48 ⁷/₁₆ x 39 ³/₈ in. (123 x 100 cm), Gift of Joey and Toby Tanenbaum, 1992.

Giovanni Battista Salvi (Sassoferrato), *Madonna*, c. 1650, oil on black marble, in. 26 x 26 in. (66 x 66 cm).

Giuseppe Simonelli, *The Battle between the Israelites and the Amalekites*, c. 1689–90, oil on canvas, 59 ¹³/₁₆ x 82 ¹¹/₁₆ in. (152 x 210 cm), Gift of Joey and Toby Tanenbaum, 1995.

Bernardo Strozzi, *Village Musicians*, c. 1635, oil on canvas, 40 ⁹/₁₆ x 62 ⁹/₁₆ in. (103 x 159 cm), on loan from a private collection.

Domenico Zampieri (Domenichino) (Attr.), *Portrait of Cardinal Cosmo de Torres*, c. 1598–1610, oil on canvas, 25 ¹³/₁₆ x 19 ¹¹/₁₆ in. (65.5 x 50 cm

Montreal Museum of Fine Arts

Anonymous, *The Golden Age*, 17th century, oil on canvas, 37 $^{13}/_{16}$ x 51 in.
(96 x 129.5 cm), Gift of Lord Strathcona and Family, 1927.
Anonymous Italian artist (17th century, Florence), *Allegorical Figure*, c. 1650,
oil on canvas, 10 $^{7}/_{16}$ x 8 $^{7}/_{16}$ in. (26.5 x 21.5 cm).
Evaristo Baschenis, *Still Life with Instruments*, c. 1665–70, oil on canvas, 32 $^{5}/_{16}$
x 38 $^{15}/_{16}$ in. (82 x 99 cm), Gift of Mr. and Mrs. Michal Hornstein, 2013.
Felice Boselli, *Still Life*, c. 1670 onwards, oil on canvas, 54 $^{15}/_{16}$ x 37 in.
(139.5 x 94 cm), Horsley and Annie Townsend Bequest, 1961.
Giovan Battista Gaulli (Baciccio), *Behold the Lamb of God*, c. 1695, oil on
canvas, 51 x 40 $^{5}/_{16}$ in. (129.5 x 102.5 cm), Purchase, Edith Low-Beer
Bequest and the Museum Campaign 1988–1993 Fund.
Giovanni Ghisolfi (Attr.), *Ruins of a Palace with Soldiers*, oil on canvas,
30 $^{1}/_{2}$ x 40 $^{3}/_{16}$ in. (77.5 x 102 cm).
Luca Giordano (Attr., or school of), *The Rape of Europa*, c. 1682, oil on canvas,
20 $^{5}/_{16}$ x 25 $^{13}/_{16}$ in. (51.5 x 65.5 cm), Gift of Mr. and Mrs. H. C. Flood.
Mattia Preti, *Tobit Blessing Tobias*, c. 1660, oil on canvas, 51 $^{3}/_{8}$ x 70 $^{7}/_{8}$ in.
(130.5 x 180 cm), Horsley and Annie Townsend Bequest, 1960.
Guido Reni (Attr.), *Saint Sebastian*, c. 1620s–30s, oil on canvas, 66 $^{15}/_{16}$ x
51 $^{9}/_{16}$ in. (170 x 131 cm), Gift of Lord Strathcona and Family, 1927.
Jusepe de Ribera, *St. Joseph*, c. 1635, oil on canvas, 28 $^{1}/_{4}$ x 24 $^{3}/_{8}$ in.
(71.8 x 61.9 cm), William J. Morrice Bequest.
Salvator Rosa, *Jason Charming the Dragon*, c. 1665–1670, oil on canvas,
30 $^{11}/_{16}$ x 26 $^{3}/_{16}$ in. (78 x 66.5 cm).
Matthias Stom, *Christ and the Woman Taken in Adultery*, c. 1630–1633,
oil on canvas, 40 x 54 in. (101.6 x 137.2 cm), Purchase, Horsley and
Annie Townsend Bequest and Gift of Mr. and Mrs. Michal Hornstein.
Bernardo Strozzi, *Eratosthenes Teaching in Alexandria*, c. 1635, oil on canvas,
31 $^{1}/_{16}$ x 39 $^{3}/_{16}$ in. (79 x 99.5 cm), Horsley and Annie Townsend
Bequest, 1959.
Francesco Trevisano (Attr.), *Mater dolorosa with Angels*, c. 1695,
oil on canvas, 25 $^{3}/_{16}$ x 19 $^{5}/_{16}$ in. (64 x 49 cm).
Girolamo Troppa, *Heraclitus*, c. 1670, oil on canvas,
28 $^{15}/_{16}$ x 39 $^{3}/_{8}$ in. (73.5 x 100 cm).

National Gallery of Canada, Ottawa

Anonymous, *Augustus and Cleopatra*, c. 1650, oil on canvas,
57 $^{1}/_{16}$ x 76 $^{13}/_{16}$ in. (145 x 195 cm).
Giovanni Francesco Barbieri (Guercino), *Christ and the Woman of Samaria*,
1647, oil on canvas, 46 $^{1}/_{16}$ x 61 $^{7}/_{16}$ in. (117 x 156 cm).
Annibale Carracci, *The Vision of St. Francis*, c. 1597–98, oil on copper,
18 $^{1}/_{2}$ x 14 $^{9}/_{16}$ in. (47 x 37 cm).
Giovanni Benedetto Castiglione, *An Offering to Pan*, c 1650–60, oil on canvas,
61 x 90 in. (154.9 x 228.6 cm).
Bernardo Cavallino, *The Vision of St. Dominic*, c. 1640–45, oil on canvas,
38 $^{3}/_{16}$ x 25 $^{13}/_{16}$ in. (97 x 65.5 cm).
Francesco Furini, *Adam and Eve*, c. 1630, oil on laid paper, 1
1 $^{1}/_{6}$ x 16 $^{1}/_{8}$ in. (28 x 41 cm).
Orazio Gentileschi, *Lot and His Daughters*, 1622, oil on canvas,
62 x 77 in. (157.5 x 195.6 cm).
Luca Giordano, *Crucifixion of St. Andrew*, c. 1660, oil on canvas, 57 $^{1}/_{16}$ x 76
$^{15}/_{16}$ in. (145 x 195.5 cm), Gift of John W. McConnell, Montreal, 1937.
Pier Francesco Mazzucchelli (Morazzone), *The Raising of Lazarus*, c. 1615–20,
oil on walnut, 15 $^{5}/_{16}$ x 21 in. (39 x 53.5 cm).
Mattia Preti, *The Feast of Absalom*, c. 1656–61, oil on canvas,
72 $^{1}/_{16}$ x 103 $^{3}/_{16}$ in. (183 x 262 cm).
Guido Reni, *Jupiter and Europa*, c. 1636, oil on canvas,
62 x 45 $^{3}/_{8}$ in. (157.5 x 115.3 cm).
Salvator Rosa, *The Return of the Prodigal Son*, c. 1655–65, oil on canvas,
78 $^{3}/_{4}$ x 46 $^{7}/_{16}$ in. (200 x 118 cm).
Andrea Sacchi, *Cardinal Lelio Biscia*, c. 1630, oil on canvas,
52 $^{15}/_{16}$ x 39 $^{3}/_{8}$ in. (134.5 x 100 cm).
Pensionante del Saraceni, *The Penitent St. Jerome in His Study*, c. 1615,
oil on canvas, 67 $^{1}/_{2}$ x 48 $^{3}/16$ in. (171.5 x 122.5 cm).
Matthias Stom, *The Arrest of Christ*, c. 1630–32, oil on canvas,
59 $^{11}/_{16}$ x 80 $^{15}/_{16}$ in. (151.5 x 205.5 cm).
Simon Vouet, *The Fortune-Teller*, c. 1620, oil on canvas,
47 $^{1}/_{4}$ x 67 in. (120 x 170.2 cm), Purchased 1957.

Vancouver Art Gallery

Luca Giordano, *The Meeting of Venus and Adonis*, c. 1653, oil on canvas,
80 $^{11}/_{16}$ x 41 $^{5}/_{16}$ in. (205 x 105 cm).

Winnipeg Art Gallery

Giuseppe Puglia, *St. Cecilia*, c. 1630, oil on canvas, 39 $^{15}/16$ x 53 $^{15}/_{16}$ in
(101.5 x 137 cm), Permanent loan (James Cleghorn Collection).